History, Theory, and Practice of Art Criticism in Art Education

by

Jim Cromer

National Art Education Association
1916 Association Drive
Reston, Virginia 22091

About the Author ...

Dr. Cromer is Professor of Art, Head of Art Education, Department of Art, University of South Carolina, Columbia, South Carolina.

About the *Point of View* Series ...

The purpose of the *Point of View* Series is to focus attention on and promote art programs that include a comprehensive approach to art learning, including the interpretation of and viewpoints on the components of the NAEA Goals for quality art education.

The authors were selected because of their knowledge of the topic. While their points of view may differ from others in the field, it is NAEA's mission to advance discussion, examination, and reflection on the content of art education.

About NAEA ...

Founded in 1947, the National Art Education Association is the largest professional art education association in the world. Membership includes elementary and secondary teachers, art administrators, museum educators, arts council staff and university professors from throughout the United States and 66 foreign countries. NAEA's mission is to advance art education through professional development, service, advancement of knowledge, and leadership.

Cover: Detail, *The Conch Divers*, by Winslow Homer, 1885. Courtesy of the Minneapolis Institute of Arts.

© 1990 The National Art Education Association, 1916 Association Drive, Reston, VA 22091

ISBN 0-937652-50-4

Contents

PART ONE — Page 1

*History, Theory, and Practice of Art
Criticism in Art Education*

PART TWO — Page 11

*Historical and Theoretical Developments
in Art Criticism*

PART THREE — Page 35

*Contemporary Art Criticism and
Art Education*

PART FOUR — Page 63

Sample Units

PART ONE

History, Theory, and Practice of Art Criticism in Art Education

Transformations in educational subject matter areas happen over long periods of time. Production of art has been the dominant area of instruction in art education for many years while areas associated with the aesthetics of viewing art have matured more slowly. This has been the case for the evolution of art and aesthetics throughout history, as well. Currently, a subject centered or discipline based approach to art education is drawing attention to the tasks of identifying how art production, art doctrine, art history, and art criticism differ, how they relate, how they consolidate to form a comprehensive whole, how they are structured by unifying concepts, and what their individual and combined uses are in society.

Objectives of the Monograph

The objectives of this monograph are to (a) present a history of the transformation of aesthetics into the three areas of art doctrine, art history, and art criticism, (b) relate historical and theoretical data to the manner in which art criticism has been approached in art education, and (c) present examples of art lessons that utilize critical theories and models.

1

Purpose of the Monograph

The purpose of the monograph is to identify instructional practices in art criticism that are based upon historical developments in aesthetics. Part one develops a context to the research problems of this monograph. Part two is an overview of major developments in the history and theory of art criticism. Part three presents major aesthetic schemes and criticism models in art education, and part four presents sample units of subject-centered lessons that demonstrate these schemes and models.

In a monograph of this size, it is necessary to limit information to the goals stated above. Some important areas of research in art education that contribute to the growing subject matter of art criticism are not included. For example, research in art education of the kinds of verbalization going on in the classroom are part of art criticism. So, too, are research projects of aesthetic preference, taste, questioning strategies, the nature of perception, reasoning, logical discourse, imagery, and aesthetic education, all of which add to the collection of information on art criticism in art education. These areas will have to be examined elsewhere.

Debate Concerning the Nature of Art and Aesthetics

Debate about the nature of art has been going on since Antiquity. But it was not until the sixteenth century that the diverse areas of art production, art history, art doctrine, and art criticism began to be distinguished as separate but related areas of art. At that time, scholars collected and produced information on philosophical doctrine, historical events, artists' lives, and critical approaches. By the eighteenth century, Kritische Herder had already observed that critical viewing revealed philosophic and cultural information. Once these areas had distinguished their contributions to viewing art, the field of aesthetics, although unnamed prior to the eighteenth century,

became an intellectual and linguistic system of inquiry based upon perception, thought, analysis, interpretation, and symbols.

Science of Art Called Aesthetics

Prior to the eighteenth century, sensory information was considered to be inarticulate perception that could be transformed into explicit perception through reasoning. German philosopher, Alexander Baumgarten (1714-1762), a specialist in scholastic logic, added a more artistic kind of perception based upon a direct, intuitive and active mode of knowing. He assigned to art its own science of viewing and named it "Aesthetics." After that, art was considered to be a visual and existential moment of directly perceiving knowledge, and modernism in art was conceived.

During this time, another development spread the influence of aesthetics. Exhibitions of the newly formed Academy of France, beginning around 1747, were open to the public. In essays written by early critics like La Font de Saint Yenne and Denis Diderot, one could see that participation in critically viewing art no longer required extensive knowledge in art theory and art history; artist, spectators, and connoisseurs were free to explore and learn new ideas, techniques, and expressive content and to make critical interpretations of what they observed in art.

During the eighteenth century, a struggle to determine critical approaches to viewing art developed among the various groups. Philosophers were interested in aesthetic theories. Art historians studied the evolution of art and culture. Critics, connoisseurs, and spectators were interested in art appreciation. Some believed in the importance of empirically identifying facts and analyzing phenomenological sensations of experience while others favored developing theories and structures of knowledge. Although development of critical techniques were delayed, it was accepted that critical aspects of aesthetics was of common interest. This controversy was

eliminated by the formulation of a coalition between people who were interested in empirical observations about works of art and those who were interested in theoretical aspects of aesthetics.

During the early part of the nineteenth century, artists, philosophers, historians, connoisseurs, and spectators approached aesthetics as a process of critical viewing that could be both scholarly and appreciative. During the twentieth century, the separation of scholarly and appreciative needs began to diminish even further, and critics soon realized that art criticism was reaching far beyond the world of art. A need to be proficient in critical viewing resulted in the willingness of a growing mass audience to ponder issues that used to be confined only to people trained in art and aesthetics.

Three important changes took place in art criticism. First, dialogues among artists, critics, and spectators, free of a prerequisite knowledge of theory and history, became linguistic "readings" that analyzed and interpreted art's expressive content. Second, as viewers gained perceptual, analytical, and interpretive skills, their interest in art production, art theory, and art history grew. And, third, because of favorable attitudes toward aesthetics, art criticism was considered to be educationally valuable.

Assumptions About Art, Aesthetics, and Appreciation

As a broader interest, understanding, and awareness expanded across scholarly and popular cultures, assumptions about art and aesthetics appeared. These assumptions, many of which were based upon theoretical information dating back to early explorations of the nature of art, affected how artists, spectators, connoisseurs, historians, critics, aestheticians, consumers, patrons, and nonprofessionals would approach art criticism.

Assumption one: Art and determination of quality.

4

Perhaps the most common assumption was that art criticism determined the qualitative value of works of art. Some of the oldest concepts of art have been that it is a science of beauty, that it provides aesthetic pleasure, and that appreciation of art is a matter of taste. Leo Tolstoy argued that these were all part of the same process of establishing value. Objects of art that possess beauty are pleasing, and explorations of beauty and pleasure refine aesthetic taste. And, art critics who were imbued with insight into art, such as Voltaire and Diderot, were needed to judge which aesthetic qualities were the best and which works of art fulfilled these qualities. Therefore, works of art that were aesthetically beautiful and pleasing to groups of people who have refined taste were identified and set the standard that was applied to other works of art.

Assumption two: Art and visual language. The capability of art to graphically express ideas and concepts has been recognized for centuries as immensely important in forming societies. Marcel Duchamp (1957) believed that judging whether a work of art was good or bad was not the most important aesthetic activity because even "bad" art was still art. A more productive approach was to interpret the meaning and content of art. This would teach viewers about the structure of art and aesthetics that is a basis for understanding and appreciating all forms human expression.

Assumption three: Nativism and aesthetics. Another important assumption was that appreciation of the aesthetic qualities of natural and designed objects was indigenous and instinctive to humans. Melvin Rader (1960) wrote that even "A natural object, such as the song of a meadowlark, has esthetic qualities; and therefore esthetics, which is the theory of esthetic objects and experiences, applies both to natural objects and to works of art. In appreciating the latter, we respond not only to sensuous qualities and forms but to technical, psychological, and cultural values—to the human expressiveness of the works" (pp. xv). Natural objects are aesthetically less complete than art because they lack an expressiveness that has grown out of an intellectual consciousness.

Assumption four: Aesthetics and critical responding.
A more recent assumption was that criticism was a function of
responding not only to the physical and formal qualities of art
but to the intellectual and cultural ideas and values they express.
Critical responding to aesthetic qualities and interpreting visual
content required the same skills and were motivated by the same
desire to understand and appreciate works of art. Even aes-
thetic explorations into art doctrine and art history required a
developed ability to respond to aesthetic qualities, which was
then followed by description, analysis, interpretation, and con-
templation.

Assumption five: Aesthetics and ordinary experience.
A characteristically modern assumption was that appreciation
was a feature of ordinary experience. Technology has provided
us with so much imagery that artistic and aesthetic experiences
have become what John Dewey (1938) called "ordinary life-
experiences" (p. 73). In its ubiquitous nature, art surrounds us
with cultural artifacts and aesthetic fiction to the extent that it
serves as a window on the world and influences how we see
and interpret everyday experience. It amplifies our perceptual
awareness allowing us to see more in a world in which there
is, unceasingly, more to see. Oscar Wilde (cited in Rader, 1960)
has said that "She (nature) is our creation. Things are because
we see them, and what we see, and how we see it, depends on
the arts that have influenced us" (pp. 20-21).

Integration of Subject Matter Areas of Art Education

The growth and refinement of aesthetics and the need and
desire of the public to become more visually literate and to
understand art has shifted the emphasis in art education to the
study of both art and aesthetics. And, historical categories of
separate but complementary activities have formed a subject
matter of art education. The oldest activities in art were the pro-
duction of art objects and philosophical speculation about the
nature of art. More recently, art history and art criticism emerged
as activities that provided information about the evolution of

6

art and the analysis and interpretation of the expressive content in art. Together, with philosophic doctrine, they form the aesthetics of image making. In addition to the need to produce artists and designers, art and aesthetics provided training for those who would become historians, critics, philosophers, connoisseurs, and spectators.

An inherent problem of subject centered curricula has been the identification of concepts around which subject matter areas could be integrated. Three concepts have appeared over the years; production, expression, and appreciation. Melvin Rader (1960) called these concepts the creation of art, the art object itself, and the act of appreciation.

Production as integrative concept. What is produced by art and aesthetics are of different material. Art is an activity of creatively making a physical art object. Aesthetics produces sensitivity and knowledge through perceiving, contemplating, analyzing, and interpreting a work of art's qualities and through appreciating and articulating its spirit. The artist creatively authors the expressive object; the viewer studies and creatively interprets what is expressed. For art to fulfill its social and cultural objectives, the contributions of both artist and spectator are required. Marcel Duchamp (1957) described the creation of art as an act "not performed by the artist alone; the spectator brings the work in contact with the external world by deciphering and interpreting its inner qualifications and thus adds his contribution to the creative act" (p. 23).

Expression as integrative concept. Morris Weitz believed it was commonly accepted that through an art object, people expressed feelings and moods. Kritische Herder anticipated in the eighteenth century that art and aesthetics were intellectual and linguistic systems of inquiry and communication. Within this concept, the goal of art education was teaching people a visual language system for expressing thought, ideas, feelings and opinions. (Carritt, E. F., 1951) Art educators would teach about mankind's oldest and perhaps most revolutionary graphic language. In the words of Ernest Boyer (cited in Getty,

7

1985), President of the Carnegie Foundation for the Advancement of Teaching, "aesthetic literacy is as basic as linguistic literacy" (p. 8).

Appreciation as integrative concept. In the past, art appreciation has been a goal of art education. But, it was subordinate to activities of producing art and studying art history. But, a major outcome of all areas of art and aesthetics has been to appreciate and cherish works of art. Considering the level of viewing skills of spectators of art and the need for developing aesthetic perception and comprehension of aesthetic objects, art appreciation could eventually, through a subject centered approach to art education, become one of the most important goals of art criticism.

An examination of the relationship among art production, the expressive object, and art appreciation, reveals that they are interdependent. Art appreciation involves perspicuity and through appreciation, artists and spectators gain clear perception and explicit recognition of aesthetic qualities. But, the expressive object provides the mechanism for acquiring an articulated vision. In creating works of art, the artist instills in an object that which is held to be of value and importance by society. Appreciating art objects involves identifying qualities of things and giving them significance and value. When a work of art is "read" it is appreciated for the depth and breadth of cultural information, ideas, and concepts it communicates. The creation and appreciation of expressive art objects provides us with an opportunity for a refinement of the instinct to gain insight into the beauty of natural and designed objects and events and make them part of our common experiences.

Importance of Art Criticism

Since aesthetics emerged in the eighteenth century as a philosophic field of inquiry and knowledge and art criticism opened the world of art to the public, the influence of art imagery on society has increased. During the nineteenth and twentieth

centuries, the expansion of technologies of imagery has caused a communications revolution that has increased its influence even further. Modern societies are saturated with imagery, and the public is pressured to consume enormous amounts of visual information to the point that, educationally, it has become essential for all citizens to be articulate in visual language systems. Art criticism has become the storytelling aspect of art and aesthetics and transforms visual experiences into verbal expressions that can be shared with others. This makes processing and utilizing so much imagery a social activity in which all people can and should participate.

1. Art reflects society
2. Beauty / decoration / truth — idealization
3. Feeling · mood · expression
4. Propaganda
5. Illustration
6. Style
7. Revolution / evolution / shock / novelty

8. Hist. Periods
 Styles
 Academy
 Isms.

9. Mart · Value
10. Taste
11. Genius

Great Art
Jojo · Over-there · mount
Michael Wayne
noise $ + art mart?
Old dogs—
art c paul caveat
mon + mopones?
van Eyck
Der Vrieslede
Benvenuto Cellini
bed + the goose

PART TWO

Historical and Theoretical Developments in Art Criticism

Countless theories of the nature of making and viewing art have emerged over the centuries. For example, it was thought that aesthetic qualities of works of art were revealed through critically viewing, contemplating, studying, and interpreting experience. Another was that aesthetics led to appreciation and was a natural part of ordinary experience. Still another approach held that art and aesthetics synthesized what we feel to be true with what we know to be facts. Art and aesthetics were thought to be a visual language involving both the production and interpretation of visual symbols. And, the meta-linguistics of art criticism was thought to transform subjective values into social objectivity. We not only knew what we held to be of value but we knew the structure of our beliefs. We learned how and why we select, abstract, and amplify facts to construct a world perspective.

Aesthetics in Antiquity

Theoretical approaches are important because they form the perceptual basis for aesthetics and determine how one will approach art, intellectually and physically. The Greeks worked their way through three important approaches: objective, subjective, and interactive aesthetics. Initially they were not

interested in searching for human values. They wanted to identify facts about the creative act, the art object, and appreciation that could be molded into objective standards against which artists could measure their achievements. But, standards revealed the subjective side of art and aesthetics. Plato and Aristotle saw the polemical reality of art in its imitations of natural laws and the subjective ideal of beauty in nature. Eventually the objective-subjective paradox was solved by determining how these two movements interacted.

Early Critical Schemes

Although early philosophers like Pythagoras of Samos (582-500 B.C.) recognized the relationship between subjective and objective approaches to art and aesthetics, they believed rationality was obtained through objectivity. To them, the relationship among physical elements created a form that gave the spectator a view of an intellectual reality beyond the senses. Eventually, Rene Descartes used this approach to identify aesthetic qualities that resulted in distinct and universal ideas. A modern application of this rationalistic approach can be seen in the statement by Michael Polanyi (1964) that, "Discovery of objective truth in science consists in the apprehension of a rationality which commands our respect and arouses our contemplative admiration; that such discovery, while using the experience of our senses as clues, transcends this experience by embracing the vision of a reality beyond the impressions of our senses, a vision which speaks for itself in guiding us to an ever deeper understanding of reality" (pp. 5-6).

But, the Greeks also noticed that as subjectivity in art grew, so grew the use of color. Pliny, Vitruvius, and Lucian all believed that taste for the decorative qualities of color was uncivilized and resulted in the decline of art. Out of the conflict between the objective content of form and the subjective content of color, between rationality and intuition, between beauty and emotion arose schemes that would eventually be considered Classical and Romantic. In order to solve these

contradictions, critics became interested in the interactive aesthetics of rectifying opposites, paradoxes, and antinomies. Plutarch (46? - 120? A. D.) theorized that opposites existed within art for the purpose of accentuating each other. He believed that objects were defined by their actions. But the nature of action was shaped by the context in which the objects were involved. This led to a synthesis of the inward world of the mind and the outward world of objects.

Criticism in Antiquity

Critical problems of art were initiated but not solved by antiquity. Art criticism emerged in Greece around the third century B.C. and concentrated upon the relationship between judgments of works of art and artistic personalities. This approach would be reinstated in the Renaissance. The lives of artists and their works were examined for theories and ideas that could be used to describe styles of art. The use of criticism revealed the pictorial effects of a work of art as well as artistic genius. But it was not until the eighteenth century that scholars identified art doctrine, histories of art, and art criticism as areas of aesthetics.

From the Roman philosopher Plotinus, in the third century, to the work of St. Thomas Aquinas (1225? - 1275), in the thirteenth century, thought developed continuously toward modern aesthetics. Emotions and ideas were considered to have universal and infinite value. But the intuitive, ecstatic, and spiritual qualities in art were revealed through an analysis of aesthetic elements within a visual context. The pleasure of criticism was found in the discovery and recognition of the "content" of the images. Art cultivated an empathetic sensitivity that was shared by all people, and so from Christian Rome to the beginning of the Medieval age, connoisseurs emerged as collectors of art. They were thought to possess a refined aesthetic sense, an ability to describe the qualities of works of art, and the intellect to give reasons for what they saw. Lucian and Kallistratos (cited in Venturi, 1936) summed up this

13

remarkably contemporary approach to art criticism. "A work of art requires an intelligent spectator who must go beyond the pleasure of the eyes to express a judgment and to argue the reasons for what he sees" (p. 50).

Merge of Classical and Medieval Aesthetics

St. Augustine (354-430 A.D.), John Duns Scotus, (1265?-1308), and St. Thomas Aquinas (1225?-75) transformed the aesthetics of Antiquity into a system of Spiritualism. Medieval aesthetics abandoned emotionalism for an empathetic approach to experience and added a new and powerful condition to rational materialism and interactive aesthetics; compassionate spiritualism. Earlier, interactive aesthetics had formed a bridge between direct sensory experience of objective rationalism and symbolic expression of subjective idealism. Now, sensory experience was abstracted into spiritual realities through which viewers could see the metaphysical world of God. As reason was replaced by empathy, external comprehension was replaced by insight, and beauty was replaced by ecstasy. Medieval art elevated aesthetics into a kingdom of the sublime that was imbued with infinity.

Art Criticism and Medieval Spiritualism

The inwardness of logical and subjective criticism in Antiquity was foreign to early Medieval spiritualism. St. Augustine promoted an aesthetic of the Free Will in which the viewer could see the sublime directly through art. Through contemplation, which was a combination of empathy and reasoning, artists and spectators became aesthetically sensitive to the assimilation of knowledge. Criticism was divided into three parts: (a) mystical naturalism, through which artistic ideas emanated from nature, (b) symbolic imagery, through which God's Will could be communicated, and (c) phenomenal mechanism, which held that significant forms were found

14

both in nature and the mind of the artist. But, all three were part of the larger body of God.

St. Thomas Aquinas synthesized the three categories into an aesthetics of empathy, called Einfuhlung. He believed that people could empathize with significant forms in nature because they possessed these forms within themselves. (Venturi, L., 1936, pp. 67-68). However, the empathetic will of mankind was controlled by the good, which was instantly pleasurable, and the beautiful, which was ecstasy. This standard of good and beautiful influenced contemporary criticism in which "good" and "beautiful" art were considered to be the "best" art. Associating judgment with the beautiful results in comprehension of the sublime in life. The purpose of Medieval Voluntarism was the attainment of "Free Will" through the recognition of a true way of life expressed in good and beautiful works of art.

Artistic Genius: Transition to Renaissance Aesthetics

The early Renaissance was considered to be a "rebirth" and the beginning of a new age in art and aesthetic. In actuality, it was the culmination of a succession of developments that synthesized the three movements of Antiquity with Medieval aesthetics and transformed them into a humanistic sphere of learning. Being a bridge across which we can never return, except through the cultural heritage we carry with us, it did mark a beginning. However, many elements of the past were preserved, and others were given new interpretations. Initially, the intent of Renaissance aesthetics was to reinstate proportion and perspective over coloration, but, instead, new and dynamic ideas were added to Romanticism. It was believed that proportion fell short of being true because of the need to shown movement and feelings in human figures. In Venice, Dolce supported a concept of spontaneity in painting saying that one must go beyond the formal elements of sensory experience and transcend nature. This philosophic doctrine perpetuated the interactive aesthetics of rectifying opposites conceived in

15

Antiquity and the Medieval abstracting of sensory experience into spiritual realities.

During the Renaissance, interest shifted from a concern for the object of art to the nature of an artistic genius who could individually translate empathetic encounters with nature into theoretical knowledge and then, eventually, to a passion for the universal concept of humanism. Around 1351, Filippo Villani wrote an historical account of the lives of artists from Antiquity to the late Medieval age, and in the fifteenth century, Ghiberti wrote about the lives of artists and even performed impressionistic criticism on their works. Philosophical realities no longer imitated or emulated nature but grew out of human sensibilities. Antiquity, during which Classical, Romantic, and Interactive aesthetics transcended sensory experience and the physical properties of nature, wedded with Medieval aesthetics to create a view of art as a repository of the sublime. These four aesthetic movements eventually transformed into the Renaissance system of humanistic aesthetics. The Renaissance mind combined nature with God to create a reality that was an exaltation of humankind. Humanism was born.

Contribution of Renaissance Criticism to Modern Aesthetics

Leon Battista Alberti (1404 - 1472 A.D.) was one of the most important persons in the history of art criticism. He lived in Bologna where he was introduced to Greek and Roman art and saw the influence of Antiquity on the art of Brunelleschi, Donatello, and Masaccio. Alberti cultivated the Renaissance humanistic aesthetic that, as the center of the universe, mankind acquired knowledge through a process of seeing universals within the human psyche itself. Returning to Florence, he produced critical writings which influenced artists and shaped the Humanistic movement. This demonstrated that culture could be molded by the interaction of all the areas of art and aesthetics.

The influence of writers like Alberti drew attention to the different cultural roles of artistic performance, art doctrine, art history, and art criticism. Alberti identified the importance of the spectator by recognizing, through criticism, the Humanistic view of the Renaissance and anticipated the arrival of a science of art. The critical descriptions of writers, such as Pietro Arentino, Paolo Pino and Ludovico Dolce, became tools for creating what Stephen C. Pepper would call a "world hypothesis." Eventually criticism would be seen as the most basic of the viewing skills and a starting point through which people could participate in the broader spectrum of aesthetics.

Aesthetics of Sixteenth Century High Renaissance

During the sixteenth century, writers continued the work of Alberti by cultivating all three components of aesthetics: art doctrine, art history, and art criticism. The greatest of these works, "Lives of Painters, Sculptors and Architects," written in 1550-1568, by Giorgio Vasari, included descriptive accounts of artists' works, critical theories of art, and collections of anecdotes about the lives of artists. But, aesthetics was once again turned toward solving the problems of opposing aesthetic views of objectivity and subjectivity, and there was too much reliance on tastes whenever things became analytically difficult. Vasari had concentrated on interpreting the psychological effects of artists on art and society and continued the Renaissance aesthetic of preferring to study artistic genius over aesthetic ideals. Artists were the standards against which perfection was measured. Even though Vasari divided the Renaissance into three ages; the fourteenth, fifteenth, and sixteenth centuries, Michelangelo was his absolute standard, so when he had difficulty with other artists of the Renaissance, he committed a fallacy of criticism. He allowed his individual taste and personal preference to cloud his account of how and what a work of art communicated.

First Signs of a Science of Art

At the beginning of the Renaissance, aesthetics was based in science and mathematics, but scholars and artists in the late Renaissance began to believe that rational laws for art were not enough and resurrected the Medieval belief in the spiritual basis of art. Therefore, artists had a special relationship with God and since only God possessed absolute perfection, the intuitive vision of artists was the gateway to new theoretical ideas. Critical techniques were used to subordinate competing aesthetic theories to artistic genius. Artistic perception was refined through analysis and interpretation and then transformed into insights and aesthetic theories. Because of the need to reconcile opposing theories, flexibility in criticism was seen as an asset and pointed to a need for a system that would accommodate changes in art.

Another development of a science of art was the revival, by Cennini, of the Greek concept of imagination which was called fantasias. The human mind had the ability to see that which was not physically present. Art was used to give physical presence to abstract ideas and bring them concretely into emotional and rational existence. Unlike Antiquity, art formed an alternative natural reality. A natural artistic truth existed alongside a natural scientific truth. All of this, consolidation of aesthetic theories, the rudiments of a science of art, and formation of a critical language, were used to promote an abstract concept of moral beauty. God inspired art, artists were preachers, and critics were those who could interpret divine ideas. Art criticism established absolute authorities in matters of taste, beliefs, and conduct. A modern crisis of "tastemaking" arose at this time. Did art control a critic's interpretation of art, or did the interpretation control the production of art?

The redefinition of the objective, subjective, and interactive aesthetics of Antiquity was completed when a method of Mechanistic criticism, based upon sentiment, was added to the aesthetics of moralistic spiritualism, Cartesian rationalism, and formalistic interpretation of observations. To the scientific

intellect and the spiritualistic will was added sensibility based upon refined feelings. The Sentiment movement was a reaction to moral and intellectual constraints and recognized the importance of an affective response to the sensory qualities of works of art. The search for a perfect truth relied upon the central characteristic of artistic genius, which was talent. Artistic talent was composed of a scientific intellect that could understand the mechanics of nature, an individual will that could see beyond physical time and space, and a cultured taste that could understand the nature of sensuous and hedonistic beauty.

During Renaissance Mannerism, the aesthetic tripartite matured into a discipline that refined art doctrine, recorded and revitalized art history, and utilized critical techniques to comprehend art. But, a new interest was found in the relationship of aesthetics to the art object. It was commonly believed that true Renaissance criticism came during the Mannerist period of art. Its contribution was that it focused attention on symbolic aspects of art rather than on what could be observed directly through art. Art no longer just imitated or emulated nature or grew out of human sensibilities. It no longer simply duplicated what was seen by the eye, but drew upon the grammar of visual ideas that had been discovered and invented by other artists. (Fichner-Rathus, L., 1986) Art became the subject matter of art, and this marked the beginning of modern concerns for autonomy in art, which was called, among other things, "art for art's sake" and which represented a major breakthrough in the emergence of modern art criticism.

Perhaps the best example of a modernist approach can be seen in Gian Paolo Lomazzo's "Treatise on the Art of Painting" (1584). A Lombard Mannerist painter who became blind, Lomazzo wrote about art and promoted abstract eclecticism as a way of integrating empirical observations with symbolizations. He developed a Syncretic principle of appreciation in which objective imitation and emulation of nature and refined human sensibilities were abstracted into a symbolic expression of visual content. Lomazzo divided his approach to critical viewing into three parts: doctrine, practice, and iconography.

Doctrine was the collection of discoveries made by artists throughout history. Practice dealt with preferences one brings to art. And iconography was the literary treatment of subjects dealt with in art. A description of his approach was couched, and rightly so, in linguistic terminology. Art was valid only to the extent it contained and expressed truths. The structure of visual language was believed to be proportion and perspective. Through movement and light the viewer semantically interpreted the psychological and mystical expression of the object, and color completed the credibility of the illusion of reality.

One would think that the greatest contribution of Lomazzo to art was the synthesis of the tripartite of aesthetics, the promotion of the linguistic structure of art, and the emphasis on the autonomy of art. But Lomazzo's greatest contribution to criticism was his system for extracting abstract concepts from art. Instead of instructing artists about how they should proceed with the creative process, he interpreted what artists had accomplished through their work. And, of course, this increased the influence of the artist and critic. By distinguishing art from aesthetics, he exemplified the two major uses of art objects. Art was a tool for creating and expressing knowledge and a vehicle for communicating ideas. In developing schemes for understanding how and what knowledge was created through art, Lomazzo's work was an antecedent to a science of art.

Aesthetics of the Seventeenth Century

The development of art and aesthetics during the seventeenth century was characterized by an abundance of conflicting theories, a synthesizing of approaches to criticism, eclecticism, and a concern for taste. Artistic styles had begun to be put into classifications. There were widespread objectified tastes and adherence to rigid aesthetic principles. Critical observations had to coincide with established art, techniques of production had to be concrete, and critics utilized a refined taste but not a scheme. Critics avoided using their rational intellect and instead had an experience of art that was lived. Although not wholly arbitrary, people were free to make

subjective choices among what was offered. The result of having so many theories from which to choose was an awareness of the variety of activities in art and aesthetics. Because each age seemed to retain what had been invented previously, early forms of aesthetics emerged once again. Moralism came to the forefront and eventually Cartesian philosophy would reinstate logical analysis. Sensist and mechanistic criticism was used to synthesize the logic of Classicism and mystical naturalism of God's Will.

Eclecticism played an important part in the Syncretic criticism of Mannerism. Artists and aestheticians used critical schemes to adopt ideas and techniques of what was considered to be the greatest art of the past. An aesthetic tripartite emerged, once again, that included philosophical theorizing, history references, and critical analysis. Scanelli and Scaramuccia, two seventeenth century critics, demonstrated the transformation of criticism from a dictation of artistic laws to an historical experience of artistic doctrine. Critical discussions of art, which included historical information, replaced treatises and provided theoretical descriptions of styles around which artists were assembled into schools. This was a shift toward a science of art based upon the depiction of art doctrine and art history through analysis, interpretation, and illumination of the techniques and content of a work of art.

Taste became a dominant concern of the three major aestheticians of the last quarter of the seventeenth century. They were Gian Pietro Bellori, Marco Boschini, and Roger de Piles. Taste was acquired in two ways: through perceiving the best in art and and analysis of each artist's style of working. For Bellori, taste was based upon critical reasoning. But, he found it difficult to negate the taste of a public who preferred naturalism to abstraction, color over form, and who accepted popular subjects. Although his approach was leveled against audiences of art, the public overpowered the critic and it was the critics who found themselves with an identity crisis. Marco Boschini wrote about the time of Bellori. His approach was close to Free Will and Voluntarism in his concern for an empathetic en-

counter with art and to Sensism in his reliance upon impressions he received from his feelings. But, rather than use a critical scheme, he relied upon a refined taste and believed that as a connoisseur of art, he was an authority on all matters of "good" and "bad" art.

Roger de Piles' contribution to modern aesthetics and criticism was the belief that intelligent people, even those who do not know the principles of art, could make judgments of art, even if they could not give reasons for how they felt. He proposed that taste was inward, natural, and spontaneous and that it could be cultivated, educated, and refined. De Piles tended to synthesize the objectivity and subjectivity approaches saying that although painting came before color, it was color that gave drawing its essential form. For de Piles, taste was formed by education and followed the preferences of the artists.

Aesthetics of the Eighteenth Century

The eighteenth century was an age of social and artistic democratization. Art criticism grew in its importance as a tool for the artist, aesthetician, spectator, and, perhaps even more importantly, for the masses. With the founding of the Academy of France in 1747 came public exhibitions that generated critical reports that were no longer restricted to statements of facts and rules. Instead, historical principles and philosophical doctrines formulated in the seventeenth century were tested against a personal aesthetic reaction to works of art. Neoclassicism and Romanticism, which had reappeared in the seventeenth century, flourished. A philosophy of Illuminism was employed in the struggle to synthesize the two movements just as the interactive aesthetics of Syncretism in Antiquity, Compassionate Spiritualism in Medievalism, Sensism in the Renaissance, and Eclecticism in Mannerism all had done before. Writers, such as Rene Descartes and two German aestheticians, Anthony Raphael Mengs and Johann Joachim Winckelmann introduced a more mystical Classicism. The most cogent proponents of an intuitive Romanticism was Hamann,

Goethe, and William Henry Wackenroder, all of whom sup-
ported spontaneity and imagination over the rules bound Neo-
classicism. Illuminism sought to describe and analyze the
physicalities and spiritual presence of works of art and inter-
pret what was actually being experienced in art.

Classical tendencies have continued to emerge during
various periods of history, but Neo-classicism had a revolu-
tionary effect on art. The Neo-classicists were split concern-
ing how much they would compromise their rationalism with
Romanticism. Mengs and Winckelmann kept the belief in the
perfection of the Ancients alive by redefining rationalism.
Winckelmann used critical schemes to draw aesthetic content
directly from works of art and the statements of ancient artists.
This content was verified through analysis of contemporary
art and works were identified with one of the movement of
ancient Greece. His book "History of Art" (1764) was based
on this approach and was the first of its kind. The freedom and
imagination this approach generated would be taken up again
during the American and French revolutions. The drive for
political and cultural freedom created a reaction against those
who would believe that taste, beauty, and perfection were the
province of the elite and philosophical minds and not of ordinary
people. Connoisseurship was based upon universal taste guided
by reason. The synthesis of Greek and eighteenth century art
would eventually culminate in Idealistic Philosophy.

Romanticism was not so much a rejection of ideas of
Antiquity, but a rejection of the domineering, elite, and uncom-
promising aestheticism that grew up around Neo-classical art.
Romanticism was an art of the ordinary and an aesthetics of
the masses. In 1762, Hamann supported spontaneity and
imagination over the eclecticism of Neo-classicism. In 1772,
Goethe, at the age of twenty three, claimed that theory in art
was less a matter of an organized approach to viewing art and
more a matter of spontaneous encounter based upon one's
refined sensibility. Accepting spontaneous imagination was
a direct reaction to the need for art to be free to express about
conditions in eighteenth century societies. The change from

correct art to spontaneous interpretation of meaning inherent in a work of art promoted a linguistic function of art in society and consequently created a tool for revolutionary social change.

Romanticists insisted upon the supremacy of feeling instead of laws. Sensibilities dictated the nature of art and the relativity of taste. In the middle of the eighteenth century, a third movement emerged in which Rationalism and Sensism were rejected for imagination. Leaving explicit perception to reason and inarticulate perception to the senses, German philosopher Alexander Baumgarten (1714-1762) identified a kind of artistic perception that was a direct and intuitive approach to art as a mode of knowledge. He assigned to art its own system of mind which he named *Aesthetics* and considered it to be a new science. The purpose of criticism was to elucidate feelings in such a way that senses and reason could not. But, because of the strength of the fusion of Cartesian rationalism and neo-Platonic mysticism, an opportunity to develop a comprehensive system of criticism was lost. Rather than examining feelings stimulated by a work of art and interpreting meaning through rational study, the goal of criticism became the study of ideal beauty. Concern for artistic genius all but vanished along with appreciation of great artists. Artistic beauty was still to be found only in ancient Greece.

The Academy of France was one of the first places in which modern day exhibitions took place and its social influence on art and criticism grew in impact after 1747. In his critiques of the salons from 1759 until 1781, Denis Diderot brought about a significant change in the writing about art. Not being trained in theory, he functioned like a journalistic critic and may have even been one of the first critics for the public. His view was intuitive, much like the Voluntarism and Sensism of Marco Boschini, in his concern with felt knowledge taken directly through the senses and his reliance upon impressions he received from his feelings. His lapidary style of refined statements can be seen in his statement that "Nature makes nothing that is incorrect. Every form, beautiful or ugly, has its cause" (Venturi, L., 1936, p. 148). Goethe described Diderot as a critic

who was not concerned with correctness or incorrectness but with coherence and incoherence. Philosophically, Diderot is linked to critical theories of Bosanquet, the perceptual theories of John Dewey and Gestalt psychology, and the Organismic theory of Stephen C. Pepper in which works of art are seen as coherent unities.

Even though William Henry Wackenroder died in 1798 at the age of twenty-five, his contribution to art criticism guaranteed him a place in its history. He opposed Neo-classical rules that were empty of expressive content and supported a more democratic and Romantic system that concentrated on artists' feelings and ideas. He was against judgmental criticism and believed that spectators should interpret art without the severity of being a judge. They should be humble in their love of the work and have sympathy and tolerance for the interpretations of others. He admired the work of Durer, who, more than ironically, was considered to be the first artist of the masses.

Artists, connoisseurs, and spectators began to make their opinions known and, being free of theoretical problems, were open to new beliefs, ideas, techniques, and expressions. This marked the emergence of a mass audience and a redefinition of the roles of art doctrine, art history, and art criticism in aesthetics. Aesthetics, as a system of the mind, opened up onto a broader reality of the world. Artists participated in social and cultural change, critics provided access to cultural resources, and historians looked at current art as well as past art for ideas. Due to the freedom of the artist to express new meanings and create new symbols, art had lost its old audience of people who knew what to expect in art. The critic interceded between the artist and this new audience and provided a method of approaching art based upon spontaneity, imagination, and utilization of natural viewing skills. Art history and art doctrine became pools of information that artist and audience alike could tap to embellish the two major performances in art: making art and interpreting art. As the three areas of aesthetics began to become more distinct, people took philosophical sides. A mistrust for

modern art arose, blind faith in Ancient art brought some security, aesthetic life became cut off from contemporary life, and the battle lines were drawn between Ancient and Modern art. This was the first time a situation like this had arisen in art.

Aesthetics of the Nineteenth Century

The evolution of aesthetics until the 19th century was a progressive separation of the component parts of aesthetics: art doctrine, art history, and art criticism. The interaction among aesthetic components resulted in the development of Philosophical Idealism and the view that because art had become a philosophical science, art of the past must be examined for direction. Philological critics, archaeologists, and connoisseurs, all of whom emerged from Philosophical Idealism, concentrated on analytical, historical, and philosophical ideas found in past works of art. They accumulated enormous amounts of information on the lives and cultures of past artists, and this information was made available to contemporary artists. Philological criticism was conceived and used in the study of art history. Like books, art works were expressive documents that could be interpreted in order to understand the society and culture of the times. The need to interpret expressive content of works of art for historical and anthropological purposes provided early methods of systematic art criticism.

Many great writers emerged in the nineteenth century. Johann Wolfgang Goethe (1749-1832) approached works of art as phenomenal experiences in which one submits to the qualities of the object. Although he believed that he was approaching art as a spectator, essentially he was putting history and doctrine in perspective and making a place for modern criticism. Kant was one of the most important philosophers to write during this transition age; he believed that criticism of art revealed subjective taste. For Kant, no rules of taste could exist because feelings determine the interpretation of subject matter rather than concepts. But, in accord with art history he

believed that it was necessary to be influenced by previous accomplishments but not to imitate them.

Although Herder was Kant's adversary and admired Winckelmann's critical scheme of analyzing works of art, he believed art to be a reflection of human spirituality. Eugene Fromentin, a painter, writer, historian, and critic, believed that one could critically study master artists and nature, but beauty and inspiration were found in self analysis. He developed this idea into a belief that all reality is a matter of critical perception, therefore drawing attention to the difference between art history and art criticism. Baudelaire believed that art was an expression of the feeling, thinking, and action distinctive to an artist. There should be no rules in art or criticism but one should approach art from an exclusive point of view, partial, impassionate, political, and open to a wide perspective. He believed the real expression of beauty was Romantic, not in the choice of subject matter nor in truth but in feeling. His belief in the creative imagination as the principle characteristic of artists caused him to see eclecticism as the antithesis of art.

During the 1870's art criticism played an important part in Emile Zola's scandalous support of Manet's work. The public had come to expect Courbet's realism, but Zola presented his critical comments within the context of what Delacroix expressed in 1824: that artists must render nature according to their own temperament. To Zola, a work of art was an expression of unique qualities found nowhere else in nature. Zola had seen a revival of the primitive aesthetic and mankind's original quest for knowledge through direct perception. John Ruskin, a British art critic, too believed that criticism was based on feelings and ideas received from having an experience with art. Both felt that content was communicated through the grammatical structure of a work of art and as an expressive language; people could acquiesce to the intuitions and feelings experienced within the vivid imagery of art without necessarily having to analyze it. The artistic choice was not within nature but within the elements of the language of art.

Possibly the most important development in the nineteenth century was philological criticism. It used critical techniques to verify and corroborate sources of philosophical doctrines by determining upon what basis they were founded and then identify their historical origins in original art and written critiques. Of course, this furthered the development of the tripartite of aesthetics and established the subject of art to be production, doctrine, history, and criticism. Works of art were principal sources of historical information. Methods and schemes of interpretation were devised and resulted in a discipline that included iconography, artistic techniques, and artistic style. Eventually, aesthetics moved into a period of positivism in which intuitive, theoretical, and authoritative thought was renounced for explicitly expressed information.

Several important consequences resulted from systematic philological examination of historical works of art and literature. First, critical methods could be used by a variety of spectators to aesthetically examine works of art. Second, a tremendous amount of information, based upon excavations and critical examinations of the art of the past, was produced. Art criticism helped mankind virtually reclaim its heritage. Third, universal histories of art contributed to Hegel's search for the universal mind and Kant's universal taste. Fourth, criticism provided a history of culture that emphasized an archaeological approach and fifth, philological criticism was vital for the development of critics, contemporary consumers, spectators, and connoisseurs, all of whom were different from artist, art historians, and art theorists in their approaches to art.

Some critics and historians were especially upset at aesthetic positivism. They felt that iconography, the study of meaning in imagery, was not so much about explicitly expressed information as it was about George Hegel's universal mind. Auguste Compte had promoted the study of the phenomenon and incidence of absolute facts, and this was to have an impact upon modern criticism and art education. Others felt that a lack of critical intuition, feelings, and empathy existed. Intuitionists, such as French philosopher Henri Bergson, Benedetto

Croce, and Joyce Cary, believed art was a kind of knowing that was, unlike universal concepts of rational knowledge, a matter of direct vision of reality resulting in phenomenal knowledge. They believed art criticism moved the viewer from an intuitive experience of aesthetic knowledge to an intellectual comprehension of aesthetic concepts. Intuitions were unexpressed knowledge that had the capacity to be expressed. In its pure state it was independent of intellectual, empirical, and cognitive function. Once intuition was given form through expression, the wave of sensations were brought into an expressive reality. To intuit was to express a direct perception of knowledge. And all activity in art was believed to lead toward the perfection of one's vision as measured by its expressiveness. (Rader, M., 1960)

Empathy was believed to be one of the most valuable skills a spectator could acquire, especially for understanding contemporary art. "The word empathy was coined by Edward Titchener, in his Experimental Psychology of the Thought Process, as an English rendering of 'einfuhlung,' which means literally 'feeling into' " (Rader, 1960, p. 367). Building on German theory, outward forms of expression had to be subjected to dynamic content generated by the mind. Phenomenal or significant form, then, was created out of a viewer's ability to empathize, the vicariousness of the visual media, the ability of artists to emulate the cadence of existence, the linguistic relationship of content to form, and the syntactical nature of criticism. Studying a visual form of communication that cannot be exactly translated allowed art criticism to be a metaphysical and syntactical language.

The outcome of critical movements in intuition and empathy was Pure Visibility. Pure visibility was an outgrowth of the development of art history and theories of perception, all of which had a major effect on art criticism. Conrad Fiedler saw a need to react to naturalism and positivism by shifting aesthetics to a science of art. Although it included the concept of intuition, it excluded, for scientific purposes, the presence of feelings. Therefore, intuition was not feelings but sensitivi-

ties that were refined out of experience. Pure visibility promoted the concept of autonomy in art and productive contemplation that was a form of artistic consciousness in which artistic representation was related to vision and expression to intuition. Fiedler had brought about an important change in the direction of aesthetics by concentrating on the study of art as an aesthetic object. He promoted a direct perception of the work of art based upon its expressive powers, rather than the use of theoretical and historical frames of reference. The belief that art was a means of creative contemplation, which involved intuitive vision and representative expression, resulted in artistic form and content being viewed as a special kind of inquiry and communication based upon the perceptual and linguistic laws of aesthetic experience. Pure visibility was a Mechanistic criticism.

Modern Aesthetics

Until the time of Winckelmann, artists wrote freely on art doctrine, recorded historical art events of the time, and made critical observations and interpretations of contemporary art. In the eighteenth and nineteenth century, art historians and scholars began to look into the past rather than concentrate on what was currently happening in art. The treatment of contemporary art was left to the journalists and writers, such as Diderot and Baudelaire, who covered the French Salons and exhibitions. Art criticism flourished and concentrated on direct experience of contemporary art and promoted the development of a refined intuition. The artistry with which writers presented their observations, the camaraderie of artists and great writers, the shift of art and art criticism into the realm of political and social struggles, gave criticism enormous importance and insight into the artistic phenomena. Art became part of a commonly shared life of all kinds of people: artists, critics, spectators, educators, connoisseurs, and students. What would grow among the public was a tremendous need for critical schemes that unified all areas of art and aesthetics.

August Willhelm Schlegel had tried to fuse the areas of art doctrine, art history, and art criticism into a solitary discipline. George Hegel had recognized that the three areas of aesthetics interacted. Then, early in the twentieth century, Heinrich Wolfflin realized that visual expression was too simple if it did not include information about art doctrine and art history. He said that the process of image making is a history of the mind and is made explicit by the influence of art image on art image and form on form. (Wolfflin, H., 1932) Art doctrine provided art history with a means of relating ideas of art and the manifestation of these ideas in style. Doctrine provided criticism with an aesthetic approach to comprehending a work of art. Art history, on the other hand, provided doctrine and art criticism with examples of works of art. And art criticism provided art doctrine and art history with a tool of inquiry, expression, and communication. Art criticism, though, used both doctrine and history to enhance its process of illuminating the significance of a work of art. In doing this, it redefined and refined theoretical and historical information. All of this served as a basis for developing schemes of art criticism, which were products of the modernization of art.

When the discipline of aesthetics emerged in the eighteenth century, it had at its core a new kind of active and phenomenal artistic and aesthetic thought and knowledge. Art criticism was considered an aesthetic process of art as opposed to history and doctrine, which were products of aesthetics. Autonomy in art was a major part of the phenomenology of modernism. Rather than just being rational and logical in making decisions and giving reasons for interpretations of art, artists and spectators utilized their imagination and intuition for critical activities. Antiquity had given us an emotional, rational, and eclectic mind. Medievalism had given us the spiritual world of faith and ecstasy. These great movements came together in the Renaissance and emerged as a discovery of the freedom of his humanism. All of this set the stage for the eventual shift into Modernism. What appeared to be a concentration on the past was in actuality a transposition of major theories and practices of Antiquity, Medievalism, the

Renaissance, and Idealism into Modernism in art and aesthetics.

The development of modernism during the nineteenth and twentieth centuries marked an important transformation in art, aesthetics, and art education. What stood out as the most important character of this change was the democratization of art and society and consequently autonomy in production and interpretation of art. Aesthetics became a branch of philosophy and was made up of art doctrine, art history, and art criticism. Artists, using aesthetics as resources for their inspiration and techniques, produced art that communicated to a popular audience. Modernism rode the wave of innovations in technology and language and began to promote a linguistic role for art in society that encouraged the masses to participate as articulate spectators. As Gustave Courbet, one of the most influential artists during this transitional period, pointed out, "modernism, especially realism, was essentially a democratic art" (Wallbank, 1977, p. 447).

Aesthetics began as a philosophical study of thought as it related to art. From Xenocrates in the third century B.C. until Winckelmann in the eighteenth century, aesthetics had consisted primarily of treatises on philosophic doctrine and contemporary artists. After the naming of aesthetics by Alexander Baumgarten in the eighteenth century and the development of philological criticism, art history and art criticism materialized. Works of art were considered to be principal sources of information about art and culture. Eventually, aesthetics became a discipline of three primary activities associated with viewing art. They were art doctrine, art history and art criticism. All involve the impulse to "read" and interpret the image. The democratization of art and society, the emergence of connoisseurs and a popular audience for art created a demand for aesthetic schemes for interpreting contemporary and historical works of art.

A systematic study of history through original works of art had brought about interest in empirical methods of art

criticism and a science of aesthetics. Dialogues among artists, critics, and spectators were based upon a "reading" of the work of art and led to art criticism being used as an educational tool. As viewers gained in skills of analyzing and interpreting the image, their interest in art production, art doctrine and art history grew. John Dewey, writing about problems involved in integrating the components of the discipline of art, said that no word existed to include that which is signified by artistic and aesthetic activities. "Sometimes, the effect is to separate the two from each other, to regard art as something superimposed upon esthetic material, or upon the other side, to an assumption that, since art is a process of creation, perception and enjoyment of it have nothing in common with the creative act" (Dewey, J., 1934, p. 180). The realization by Wolfflin, that form and content cannot exist without each other and what one sees through art was not an alternative view of the same thing but another thing entirely, was in keeping with the Plutarch's theory, during Antiquity, that opposites existed within art for the purpose of accentuating each other. This led, ultimately, to Stephen C. Pepper's theories of criticism. Pepper chose the unity of form and content as his basis for theories of modern art criticism.

PART THREE

Contemporary Art Criticism and Art Education

As the 20th century began to unfold, forces that had been shaping aesthetics and art criticism began to mature. Aesthetics had become accepted as a phenomenal part of ordinary experience and all people were thought to be capable of having an aesthetic experience. John Dewey (1934) wrote that "The esthetic is no intruder in experience from without, whether by way of idle luxury or transcendent ideality, but that it is the clarified and intensified development of traits that belong to every normally complete experience. This fact I take to be the only secure basis upon which aesthetic theory can build" (p. 46). The effect of this attitude was the proliferation of aesthetic theories in philosophic doctrine, art history, and art criticism.

Art and aesthetics theories began to multiply as early as the Renaissance. From the invention of "Aesthetics" in the eighteenth century to the multiplicity of art movements in the twentieth century, art and aesthetic information grew at an unprecedented rate. This invoked a need to schematize vast amounts of ideas about art production, art doctrine, art history, and art criticism. The primary task for art and aesthetic education has been to process all of this content into usable curriculum materials. This led to a subject centered approach to art education, Discipline Based Art Education (DBAE), and a challenge to collect the work that has gone on in art and aesthetics and develop what Charles Dorn (1981) has called

35

cohesive concepts or unifying theories that can be used to integrate the subject matter areas of art education. It is within this context that models of art criticism in art education were examined.

Unifying theories are definitions of art that determine how artists, philosophers, historians, critics, and spectators approach the production and viewing of art. In themselves they are not methods of art criticism. Nevertheless, they are necessary for identifying essential aspects of art and aesthetics that determine the process of making and responding to works of art. And they identify artistic and aesthetic values which support what people say is significant in art. Several writers proposed traditions of art criticism that schematically paralleled philosophic doctrines and art history. For example, Walter Abell (1957) identified six kinds of art criticism, all of which were determined by their purposes. They were: (a) Iconography: the study of the subject matter of art objects as primary sources for understanding art. (b) Biographical Criticism: the study of creative genius and the personalities of artists. (c) Historical Determinism: gathering information on the interaction of art and society. (d) Aesthetic Materialism: the study of materials, techniques, and functions of art. (e) Aesthetic Teleology: the study of the psychological will to make art responsible for stylistic epochs of mankind. (f) Pure Visibility: the study of formal significance inherent in the composition of lines, colors, and other plastic elements.

All six approaches, though, can be divided into two categories. In the first category criticism is concerned with an intrinsic part of a work of art, while the second shows a concern for the context of creating art. Iconography, Aesthetic Materialism, and Pure Visibility examine an essential part of the physical art object. Biographical Criticism, Historical Determinism, and Aesthetic Teleology study the circumstances that causes art to happen. Given an understanding of these theories, methods of art criticism can be designed around each approach.

Stolnitz (cited in Ecker, 1970) offered another example of schematization in his five types of criticism: (a) criticism by rules, (b) contextual criticism, (c) impressionistic criticism, (d) psychological criticism, and (e) intrinsic or New Criticism. Criticism by rules classifies work according to a genre and its standards. Contextual criticism deals with interpreting subject matter. Impressionistic criticism describes ideas, images, and emotions aroused by a work of art. Psychological criticism determines the intention of the artist and Intrinsic or New Criticism guides perception to what is contained in the works of art by disclosing the meanings it imparts.

Pepper's World Hypotheses as Critical Approaches

Stephen C. Pepper made the most significant impact on art criticism in art education because his theories encompass many of the historical approaches to art criticism and are amenable to translation into teaching materials. Interaction, integration, and unification, which have been present during all ages of art criticism, are the basis for his work in art criticism. He referred to the critical method of consolidating all corroborating facts about an art object as "the world hypothesis", and each utilization of a unifying theory of art criticism produces a unique interpretation of the world hypothesis. Pepper said that out of the entire history of human thought, only four hypotheses were adequate. All are holistic processes of criticism, but each emphasizes the importance of one part of an aesthetic experience over another. And as systems of art criticism, they can be applied to current knowledge in art and aesthetics. He named them Mechanistic, Formistic, Contextualistic, and Organismic Criticism. (Pepper, 1946)

The critical process involved in constructing an hypothesis has three factors: (a) a concept of empiricism, (b) analysis of correlations and connectivities, and (c) defining, interpreting, and justifying observations in relationship to the hypothesis. (Pepper, 1946) The components of his critical process are making observations, performing comparative analysis of data

and knowledge, and defining an accurate hypothesis. Interpretations and conclusions emanate out of the construction of the hypothesis. The first component validates conclusions, the second is a process whereby facts are formed out of observations and existing knowledge, and the third is a theoretical model of interpretation that insures accuracy of the use of observations and descriptions.

Mechanistic criticism.. Mechanistic Criticism is a pleasure aesthetics and has a long history especially in the traditions of Hobbes, Locke, Walter Pater, Santayana, and Prall. One of the most important principles of Mechanistic Criticism is that aesthetics is based within physical time and space and upon the ability of the spectator to have an existential experience. Aesthetic pleasure does not come from the art object but from the phenomenal experience itself. Autonomous individuals associate with their own individuality and space, but awareness of the boundaries of their bodies results in a need to empathize with spaces beyond themselves. Although pleasure and value are subjective, introspective reporting of an external observation is objectified through comparison with responses of other viewers. When pleasure is projected into the sensory experience of an external object, its linguistic associations can be shared by others. Becoming sensitive to the linguistic structure of experience increases the viewer's capacity for enjoyment. (Pepper, 1946)

Formistic criticism. The major approach of Formistic criticism is to identify universal norms in the aesthetic materials of art objects. This is done in three ways. First, aesthetic values represent and imitate norms found in universal ideas. Second, norms are found in the perfection of physical properties of the creative act; craftsmanship, demands of materials, the artist's skills, and the art objects itself. Third, a cultural norm is found in universal expressions of an age and society. (Pepper, 1946) The intellectual norm is an indigenous system of abstractions found outside human experience but dependent upon human perceptions and representations for its existence. Its purpose is to find a state of equilibrium of the

emotional needs of the public and the demands of society for objectivity.

Contextualistic criticism. To Contextualists, integration is the most important part of art criticism, and so they concentrate not on the final unity but work from the environmental whole to the details in order to see how the connectivity of elements results in contexts. The viewer is an element in a changing human environment of which art objects are extensions. (Lee, 1944) Therefore the aesthetic reaction is not to the art object but to the interacting qualities of the entire environment. Contextualistic critics concentrate on the syncretic integration of conflicts rather than a unifying quality of the whole organization of the work. This is intended to activate our social and cultural sentiments and give us a vivid image of the aesthetic experience. Contextual artists seek out social issues, therefore investing their power in the ability to perceiving the details of social conflict. (Pepper, 1946) Works of art express content that is verified through evidence taken from society and culture.

Organismic criticism. Pepper believed that Organismic criticism was the most fruitful of all views. Organicism has as its main concern the integration of parts leading to a coherenceof ideas and concepts. The roots of organicism go back to Diderot's attention to coherence and incoherence of aesthetic structure and the perceptual theories of Gestalt psychology. Organicism defines art as an ultimate unity derived out of the perception of the connectivity of elements. Knowledge is acquired out of the integration of intuition and emotions, facts and evidence, and qualitative relationships of perception, all of which are verified by the coherence of the structure of the art object. As elements combine into more complex sets of relationships, a richer view of the world results. Organismic criticism begins with the natural drive to organize and compose elements into a meaningful and imaginative whole. Vivid intuitions and creative imagination transcend into organized perception and awareness of the quantitative elements of the art object that form the materials of an aesthetic response. The

appreciative critic and spectator analytically reconstructs, through an integration of feelings and ideas, that which the artists created. Ultimately, the purpose of Organismic criticism is to lead the viewer, through the expressive combinations of artistic elements, to views of the world which result in greater appreciation for the arts as a language and the world as a place to seek fulfillment. (Pepper, 1946)

To summarize, Mechanistic Criticism places aesthetic activity within a space-time field that contains the physical object and the viewer. Aesthetic pleasure is inherent in the phenomenal experience itself. Formistic Criticism is concerned with intellectual, physical, and cultural norms. One can experience the analysis and interpretation of factual content for the purpose of forming an equilibrium of emotional and objective needs. The Contextualist works from the whole to the part in order to understand the changes art brings about in the human environment. The critical reaction is to the art object as an perspective of the entire social context. Organismic criticism begins with the structure of a work that lead to a unity, and emphasizes the innate pleasure of working from the connections of the parts to an integrated whole. (Pepper, 1946)

Aesthetic Schemes

AESTHETIC RESPONDING SCHEMES

The study of subjective responses and expressions of feelings within a cultural context.

Doctrine	History	Criticism
1. Sensism	**1. Romanticism,**	**1. Mechanism**
Explores sentiments, emotions, feelings. Pre-rational, symbolic, autonomous contemplation. Intuitive response to existential colors, experience. Increase pure visibility, direct, subjective awareness.	Stylistic techniques express feelings and pre- emotions. Affective expression of cultural values. Enhanced space. emotion through gestural form, ambiguous space. Fluid surface, dynamic expression of moment in time.	Pleasure in aesthetic response to phenomenal experience. Based in physical time and Expression of interaction of inner feelings with external object and experience.

ANALYTIC SCHEMES

The acquisition of critical and analytical skills.

Doctrine	History	Criticism
2. Formism	**2. Classicism**	**2. Formalism**
Rationalism obtained through objectivity. Reality constructed out of physical relationship of symbols. environmental elements funding into abstracted, explicit, universal ideas. Cognitively transcends sensory experience.	Factual truths represent an ideal made visible through abstracted forms and Beauty in perfection. rational idealism. Balances emotion and restraint. Linear, geometric, symmetrical composition; technical control.	Applies aesthetic materials to universal cultural norms. Physical and technical Experience of factual, intellectual, universal ideas as basis for aesthetic values.

INTERPRETIVE SCHEMES

Acquisition of skills of integrating opposites to produce an expanded view of reality.

Doctrine	History	Criticism
3. Syncretism	**3. Hellenism**	**3. Contextualism**
Interactive post-analytical aesthetics of rectifying opposites, paradoxes, and antinomies. Transcended sensory experience. Balance of external and internal worlds of experience.	Excessive, theatrical emotionalism and illusion to heighten realism. Simplicity and idealism. emotionalism and serene symbolism. Natural push and pull of opposites.	Significance of unified whole of aesthetic environment. Syntactical Harsh connectivity of elements. Social issues and conflicts accentuated. Verification through social and cultural context.

UNIFYING SCHEMES

Spontaneous and creative imagination to see infinite possibilities.

Doctrine	History	Criticism
4. Voluntarism	**4. Medievalism**	**4. Organicism**
The empathetic will resulting in feelings of pleasure and ecstasy. Transcends the materialistic, physical, emotional, and intellectual worlds for infinite world of spirituality.	Transports viewer from the earth-bound realism of the everyday world into a universal expression of mind. Abstract, decorative, and symbolic fantasy worlds of super realism.	Integration of parts into coherent ideas and concepts. Pleasure in working from the connections of elements to an ultimate unity. Integration of intuitions and emotions of evidence and facts into universal mind.

Art Criticism in Art Education

The 1960's were a major watershed in the history of art education. The child centered movement had come to fruition and research and development had turned toward the task of establishing a subject centered approach to art education. Major programs were established to study aesthetic education, and in July and August of 1966, Edmund Feldman, along with Eugene Kaelin and and David Ecker, conducted a seminar on art criticism at the Ohio State University that had a major impact upon the direction of art criticism in education. The Ohio State Seminar was part of an Institute for Advanced Study in Art Appreciation and was sponsored by the United States Arts and Humanities Foundation. The purpose of the seminar was "to bring the resources of art history, philosophy, and art criticism to bear upon the problems of art appreciation in American secondary schools" (Feldman, 1968). What grew out of this seminar was a major approach to art criticism, attention to the aesthetic tripartite that had been forming since antiquity, and clarification of the aesthetic constituent of a subject centered curriculum.

A major conclusion of the Ohio State Seminar was that "what an art teacher does - whether in art appreciation or studio instruction - is essentially art criticism. That is, art teachers describe, analyze, interpret, and evaluate works of art during the process of instruction" (Feldman, 1968, p. 24). Therefore, models of criticism should be used during the production of art and during the teaching of art doctrine and art history. Another conclusion was that aesthetic education should be active rather than passive. In the passive kind, the audience expects an "expert" to tell them what they are seeing. In an active appreciation, spectators become involved in using criticism to inquire into the nature, art, what and how art communicates, and the cultural heritage that art has given them.

Feldman pointed out that teachers don't recognize all of the kinds of talk going on in the classroom as being criticism because of the overriding notion that art criticism is performed

only by journalists. Teaching about art doctrine and art history requires talk about art. So does art production. And each kind of discourse involved in art and aesthetic activities has its own particular character and purpose. Many of Pepper's ideas are compatible with this kind of educational setting and have influenced the important work of Edmund Feldman, although some views have been modified. For example, according to Feldman, forming a hypothesis is an extension of interpretation. During description and analysis, explanations present themselves spontaneously, unfold gradually, and must conform to the evidence. Interpretation integrates description and analysis in a meaningful way and results in an hypothesis. Feldman identifies three approaches to art criticism: Formalism, Expressivism, and Intrumentalism, all of which are used by the journalist, teacher, scholar, spectator, and artist. (Feldman, 1985)

Feldman described Formalism as a theory of communication that supports the idea that excellence exists in formal relationship and composition of physical elements. The Formalist believes that art criticism identifies universal and ideal norms. Expressivism approaches art criticism as a means of comprehending the intense and vivid feelings and ideas that transcend reality. Feldman wrote, "Expressivist criticism sees excellence as the ability of art to communicate ideas and feelings intensely and vividly." Instrumentalist criticism is used for cultivating some social, moral, religious, political, or psychological influence, and excellence is based upon the consequences art brings about. (Feldman, 1985) All three processes are followed with a comparison of the work with art of the past.

Feldman believed that the behavior of a critic could be schematized and taught in art education. His model includes four parts: description, analysis, interpretation, and judgment. All of these components of art criticism are common throughout the history of aesthetics. Description involves becoming aware of items in a work of art by taking inventory of what is visible in the object. The words are pointers and allow the group to agree upon what is seen and to construct a "complete and

neutral inventory" (Feldman, 1970). The purpose of description is to point out expressive shapes, colors, spaces, and volumes and artistic techniques. Feldman said that "In order to be impartial or neutral, you have to watch your language, avoiding loaded words or expressions that reveal feelings and preferences" (Feldman, 1970, pp. 350-351). No reference to meaning or value is made at this point in the critical process, and it appears that spectators need to have a foundation of knowledge in design, technique, and production. This is in contradiction to the notion that emerged during the time of Denis Diderot and the salons of the French Academy that criticism could be performed without knowledge of philosophic doctrine, art history, or art production.

Analysis describes how these things relate. Spectators analyze the formal elements of a work of art by comparing the design relationships with the elements and principles. These are things that can be noticed about the composition and the arrangement and character of the figures. Feldman believed analysis could tell the viewers about emotions and ideas, but generally he kept the discussion primarily about structure and composition. (Feldman, 1970) Also, he believed that "archaeological, historical, or literary data about works of art may be fascinating but not necessarily useful in art criticism" (Feldman, 1985, p. 457). Information that is not visually part of the work is eliminated.

Interpretation is a process of identifying themes and ideas, becoming aware of emotions and meanings in works of art, and forming an integration of descriptive and analytic observations. Feldman considered this stage to be the most difficult, the most creative, and the most rewarding. "A critical interpretation is a statement about a work of art that enables the visual observations we have made to fit together and make sense. In other words, what single, large idea or concept seems to sum up or unify all the separate traits of the work?" (Feldman, 1970, p. 362). To Feldman, an interpretation was an explanation of a work of art. But he believed in right or wrong hypotheses rather than in looking at those that test truths and rectify paradoxes.

He said that "It is difficult to be right at the first try. In fact, being wrong—missing the target—is very helpful in arriving finally at a convincing explanation" (Feldman, 1970, p. 363).

Judgment involves making decisions of value, worth, and success, and giving the work of art a rank in relation to other works of its type. Feldman wrote, "For many of us, deciding whether a work of art is worth serious attention is one of the most important problems of art criticism....To become a 'judge' of excellence, it is helpful to know how good 'judges' or critics decide whether a work is poor or excellent" (Feldman, 1970, p. 371-372). Value judgments are the final act of art criticism.

Feldman provided a crucial service to art education in his adaptation of some of the theories of Stephen C. Pepper into a model of art criticism that could be used in a discipline based art education curriculum. It is even more significant when one considers that Pepper's theories summarizes centuries of work in aesthetics, therefore giving Feldman's model of art criticism a structure based upon accomplishments extending back to antiquity. Although Feldman believed in the pleasures of an aesthetic experience, his approach does not relate, significantly, to the phenomenal time and space experience of Mechanistic criticism. Feldman's critical process is object oriented and concerned with the intellectual, physical, and cultural ideas expressed in the coherent artistic form. His description, analysis, and forming of an hypothesis out of an interpretation of parts do relate to Organismic criticism. But, unlike Organicism, Feldman's model is more interested in giving reasons for judgments and making sense out of visual evidence than in a ultimate unity.

Feldman is closely aligned with the Contextualist in his concentration upon details, analysis, relations, and diffusion; his detachment from emotions; and his concern for the cultural environment of the viewer. His approach to criticism is most compatible with the ideas of Formalistic Criticism. The primary method of the Formalistic Critic is to search for intellectual norms in universal ideas, the physical qualities of the end

product, and cultural standards with which to make judgment of art. His model requires reasons to be given for interpretations and for the aims and purposes of the work. Feldman intimated that the process of finding agreements and normalities is how people made sense out of what they experience. (Feldman, 1970) As a form of communication, interpretation of content is achieved through the verifiable observations of formal relationships within a work of art.

Eugene Kaelin's contribution to art criticism is in establishing the idea that aesthetic education is a social function that teaches the use of artistic communication to develop human personality. People are supplied with enriched situations and alternatives through an appreciation of "values" found in works of art at a given moment of experience. (Kaelin, 1968) Four principles are the basis of his approach to aesthetic education. They are: a projectional principle, which helps people make progress through instruction, an autonomy principle, which means that values are inherent in artistic communication, a relevance principle, which bases aesthetic procedure upon description of works of art and their inherent values, and a completeness principle, which holds that students must go beyond expression and concern themselves with the value of the work of art. (Kaelin, 1968)

Kaelin's phenomenological method strives to achieve empirical adequacy, logical consistency, and universality by limiting aesthetic experiences to facts observed within works of art. These "relevant" facts are created out of "descriptions or postulates which harbor no self-contradictions" (Kaelin, 1968, p. 5). The observation of empirically adequate, logical, and universal facts allows viewers to generate reasons for a work's value based upon descriptions of its structure. Aesthetic knowledge, cognized through the senses and constructed in the mind, determines what works succeed or fail in aesthetic expressiveness. He rejected subjectivity, which he called an "affective fallacy." The free association of the subjective mind allows criticism to move too far from the meaning intended by the artist and results in only microcosms of universal norms.

These ideas result in a technique, employed by Kaelin and others, called "bracketing" aesthetic perception. By partitioning off the aesthetic object and concentrating upon how the object affects our perception and cognition, it is believed that Husserl's "phenomenological epoch" will be achieved and the viewer will have a pure aesthetic experience. Kaelin wrote, "All we do in effectuating the phenomenological epoch is to place brackets around the appearance of the object, so that the physical characteristics it displays, from the standpoint of the natural attitude, are held to be irrelevant" (Kaelin, 1968, pp. 31-32). The spectator then recognizes the difference between the physical, which is linked to the rest of the world, and the aesthetic, which is embedded in the experience of an art object. Once nonessential characteristics of the physical artifact are bracketed out, value-neutral counters, which replace categories of content, form, elements, and principles of organization, fund into a closure that completes the aesthetic encounter. The primary aesthetic activity is the judgment of a work's significance or value and is based upon the "felt expressiveness of the funding counters" (Kaelin, 1968, p. 34).

David Ecker's major contributions were in recognizing the dominant role of art criticism in aesthetic education and the need to possess an "openness" to an aesthetic experience. He wrote "The making and justifying of aesthetic judgments will be the core of aesthetic education, whether these activities are exemplified in linguistic or non-linguistic behavior" (Ecker, 1970, p. 52). Furthermore, criticism is paramount for activities of both the artist and the spectator. In fact, Ecker favored critical techniques that are based upon artistic viewing and responding to art. He believed the artist controlled the process of making art by being sensitive to his own aesthetic responses to the work in progress and visualizing the results of possible aesthetic alternatives.

To perform critical artistic judgments, according to Ecker, the viewer must possess an openness to sensory experience and receptivity to aesthetic phenomena. He proposed that reflecting upon and describing qualities, ideas, feelings, and associa-

48

tions in an aesthetic experience allow the viewer to decide which of these elements are aesthetically relevant. Ecker's concern was to avoid using a set of theoretical criteria to judge works prior to having an aesthetic encounter. He believed this to be a phenomenological approach that was "well-suited to studio trained students who are interested primarily in the aesthetic rather than the historical, philosophical, or social foundations of the arts" (Ecker, 1970, p. 53). The approaches coming out of the Ohio State Seminar were mainly formalistic and phenomenological and concern was with what is empirically seen and constructed as an aesthetic experience. But they did little to utilize the intuitive and cognitive knowledge one brings to an experience or the cultural epoch out of which they arise. The Ohio State Seminar set the trend for art criticism in art education, but even more importantly, it drew attention to the amount of aesthetic theory that must be integrated into education in art criticism.

Along with Feldman, Harry S. Broudy had a major impact on the teaching of art criticism. Broudy's approach to art criticism places special emphasis on phenomenological objectivity, also, but contains elements of other aesthetic schemes, as well. His approach includes the creative imagination and unification of the whole found in Organismic criticism and the emotionalism and universal taste of Contextualism. For example, Broudy believed aesthetic experiences enlighten us about the nature of feeling and the goal of phenomenological objectivity is subjective value education. (Broudy, 1972) Broudy was faced with the same paradox as the ancient Greek classicist and romanticist. To explicate the dilemma, Broudy proposed a theory of visual expression. Within this theory, the substance of value is the expressiveness that is perceived to be an inherent quality of the art image. Seeing expressiveness to be within the image itself maintains phenomenological objectivity. (Broudy, 1972) Joshua C. Taylor (1957) described this as "expressive content" (p. 43). What we subjectively project into a work of art, due to our own personal and cultural experiences, is objectified in the physical form. Idealism, a synthesis of Romantic content and Classical form, represents the truth

49

of an ideal made visible through abstracted symbols. A balance occurs between the idea and the form of art.

Broudy devised a multifaceted model of art criticism involving five categories: (a) aesthetic factors, (b) analysis, (c) evaluation, (d) sequence, and (e) outcome. He believed that all works of art, regardless of method and media, can be examined and evaluated with consideration to aesthetic factors of sensuous materials, technique, formal design, expressiveness, interest to perception, and purpose. (Broudy, 1964) The analysis of works of art begins with aesthetic scanning, which involves observation of sensory elements of design, formal principles of design, technical use of materials, and expression of mood reflected in the work. The discourse that follows aesthetic scanning describes the content and structure of the work, the conformity of the work to a rule or principle, and the potentialities the artist might have realized but did not. (Broudy, 1964)

The sequencing and interacting of the parts of Broudy's model produces the aesthetic materials of illumination and evaluation. The sensuous properties require discrimination achieved through description of elements of design. The technique and formal design of the work require comparison to principles of form. Expressiveness of a work of art requires giving attention to subjective impressions of meaning. And to transcend the aesthetic, one must judge the work according to its use and purpose. (Broudy, 1964) Broudy believed that art criticism first involves explication and then an appraisal of its value and excellence. At this point in the critique, the viewer judges the quality of the work of art. This is accomplished by classifying and identifying the object, interpreting its intent, effect, and significance, and measuring its level of success against some interjected ideal, standard, or criterion. To perform judgments, Broudy believed that one needs knowledge of aesthetic theory, art history, and art criticism.

Ultimately the outcome of art criticism and value education leads to increased aesthetic sensitivity, which is the abil-

ity to discriminate, analyze, and distinguish elements and principles of composition that lead to formal unity and to what Broudy called enlightened cherishing. Cherishing is a special kind of love and desire. Rather than simply possess objects, cherishing causes people to find delight in the intrinsically valuable properties of objects that fulfill the norms and standards they acquire out of knowledge. (Broudy, 1972) Expressive properties are an empirical part of the image, and viewers identify with them through their own value systems. Therefore, the subjectivity and phenomenal objectivity are unified into one aesthetic whole.

Ralph A. Smith assigned art criticism the lofty goal of furthering humane values. To achieve this goal, Smith proposed that schools effect in students an intelligent interpretive perspective; an ability to perceive, understand and appreciate works of art. (Smith, 1973) He proposed two kinds of art criticism—exploratory and argumentative aesthetic criticism. The purpose of exploratory aesthetic criticism is to sustain aesthetic experience. Having attained an aesthetic experience of a work of art, aesthetic argument communicates and defends an account of the work's "goodness (or poorness)" (Smith, 1973, p. 39). Possibly Smith's most important contribution to art criticism is the distinction he draws between acts of discernment and judgment.

Smith proposed overlapping phases of description, analysis, characterization, and interpretation. Description entails naming and identifying a work's representational elements of subject matter and formal divisions. Smith supported the contention that to perform adequate description, one must possess knowledge of art history and aesthetic theory. Formal analysis of the relationship of elements involves identification and characterization of these associations. Analysis and characterization set the stage for interpreting a work's meaning and content. Exploratory criticism does not necessarily mean that evaluation and judgment are suspended in favor of a neutral account of the work's properties. (Smith, 1973) Interpretation is a kind of summary judgment of all pertinent knowledge,

experience, and sensitivity that can be engaged by the viewer. A characteristic of exploratory criticism is that an appraisal of the work's aesthetic worth is inherently a part of the process of describing, analyzing and interpreting. According to Smith, the language of examination and interpretation is normative. Describing, analyzing, and interpreting works of art are viewed as being a different process from making justifications to support evaluative conclusions. Yet, critical examination is a prerequisite of aesthetic argument.

Smith provided a scheme, based upon theories of art, for argumentative criticism the produces evaluations of a work's aesthetic merit. His process for critically appraising works of art includes: (a) an encounter with an object of value, (b) forming value terms, such as remarkable, magnificent, or marvelous, that rate the aesthetic import of the work, and (c) giving reasons, such as a work having an "immense aspect of drama....and a deep harmony built of a wonderful finesse, " that justifies the work's value. These reasons reflect (d) aesthetic standards, such as unity, complexity, or intensity, that are qualities of theories of art. (Smith, 1973) To make critical judgments of art, according to Smith, one must be linguistically fluent, have an understanding of the subject matter of art, and know a variety of aesthetic theories. Smith's critical approach is educationally sound, especially in his model for making judgments of value. But, like the other processes described above, it requires a student to have an advanced level of a priori knowledge, a refined perception, and capability with language and reason in order to be effective.

Although, at first, it appears that Gene Mittler is basing his approach to art criticism primarily upon the work of Pepper, Bruner, and Feldman, in actuality his work is reminiscent of the philological critics who developed the aesthetic tripartite of subject matter that includes philosophical theorizing, history references, and critical analysis. Philological critics used criticism to gather historical knowledge and to verify philosophical doctrine that accompanied trends in art. Mittler's methods for teaching critical skills go beyond the intent of the

philologists by including a judgmental goal of identifying worthwhile art. Aesthetics is, in his words, "to instill in these students the capacity to critically examine various works of art, discuss the aesthetic qualities identified in them, and formulate personal judgments pertaining to the degree of aesthetic merit noted in each" (Mittler, 1973, p. 16).

Mittler's system has two components: theories of art and art criticism operations. Theories of art are used to identify various aesthetic qualities of works of art and to teach students "what to look for" (Mittler, 1980, p. 19). Imitationalism, Formalism, and Emotionalism are advocated because of their familiarity, their relative simplicity, and their compatibility with his strategy for examining works of art. The aesthetic qualities to be identified are literal subject matter, visual surface, structural organization, expressive ideas, and feelings.

Mittler uses Feldman's description, analysis, interpretation, and evaluation model of art criticism as an "observing strategy" to isolate, identify, and examine aesthetic qualities during an encounter with actual works of art. He believes this teaches students "how to look" at works of art. According to Mittler, description is the process of taking inventory of literal qualities of representational subject matter and elements of aesthetic form, which have been described by Kaelin, Broudy, and Taylor as "expressive content." While analysis examines the visual qualities of relationships among the components that make up the aesthetic structure, interpretation distinguishes expressive qualities and meanings inherent within the structure. Judgment is a process of deciding upon the degree of the work's aesthetic merit supported by information collected during preceding parts of the model. Although Mittler did not provide a method for determining how to quantify the aesthetic merit a work possessed, he did provide an opportunity for students to rationalize their decision based upon examination. And, the four part observing strategy is used to study each aesthetic quality within a theory of art.

When Mittler adopted Jerome Bruner's theories of dis-

criminate perception his approach became even more comprehensive. Mittler's interpretation of Bruner's four stage model is (a) a crude scanning operation called Premature Decision-Making, (b) Searching for Internal Cues leading to more discriminate decision-making, (c) Searching for External Cues that confirm decisions, and (d) Final Decision-Making that ends cue search and finalizes judgments. Mittler does not give much attention to premature decision-making, even though this would have linked his work with the critical intuition and direct perception of Contextual Criticism, the empathy of Organismic Criticism, and the autonomous contemplation of Mechanistic Criticism. Searching for internal and external cues is used to support final judgments of artistic merit. During the search for internal cues, Feldman's critical model of description, analysis, interpretation, and judgment is applied to theories of art to identify the work's aesthetic qualities. During description students study the literal qualities of Imitationalism by making accurate descriptions of subject matter. During analysis, students study organizational qualities of Formalism by examining principles of art that organize the elements of art. During interpretation, students study the expressive qualities of Emotionalism by identifying the feelings, moods, or ideas communicated by the work. During judgment, personal determinations about the degree of artistic merit are made.

A search for external cues is an historical operation in which students determine how others have interpreted and evaluated works of art, and they either confirm, modify, or reject their previous interpretations. To maintain consistency, Feldman's four part criticism model: description, analysis, interpretation, and evaluation is used in the search for external clues. (Mittler, 1980) Mittler believes that critical examination and evaluation of art stimulate interest in the study of art history. He stated that "During art criticism, students temporarily disregard historical data in order to focus complete attention on works of art." He calls this an art criticism/art history approach to appreciation requiring no previous experience in art history or art criticism. (Mittler, 1980, p. 19) However, an examination of Mittler's approach to art criticism

reveals that it relies heavily upon theoretical and historical knowledge in art to perform all of the critical steps. According to Mittler, success in observing works of art is based upon the spectator's having prerequisite art knowledge. "Identification of aesthetic qualities as stressed by different theories of art would seem to be an essential prerequisite to experiences dealing with observing strategies" (Mittler, 1973, p. 18). To avoid the pitfalls in deciding which comes first, a direct encounter of art or acquisition of subject matter, Mittler makes acquisition of art knowledge a step in his criticism model.

Louis Lankford proposes a method of art criticism that is based upon a phenomenological approach to describing art. The goals he identifies for art criticism in art education include (a) forming a closure for processes of making art, (b) developing visual literacy and appreciation, (c) increasing one's base of knowledge and experience, (d) stimulating cognitive and affective processes, and (e) increasing awareness. These goals are achieved through the critical procedure of revealing the expressive significance found in works of art. As is the case with many of the other approaches to art criticism, Lankford believes that "the work of art be delimited....and that the viewer is equipped with some prior understanding of what constitutes relevant critical dialogue" (Lankford, 1984, p. 152).

Lankford's critical method, although similar to others in art education, shows a greater concern for interactive aesthetics and the need to provide for a holistic perception of subjective and objective information. His method is based upon several propositions derived primarily out of the phenomenological doctrine of Merleau-Ponty and Eugene Kaelin and arranged into three groups: necessary conditions for critical dialogue, assumptions about the nature of the critical act, and positive outcomes of performing art criticism. Concerning essential conditions for criticism, Lankford proposed a long list. He believes meaning is derived out of an intentional act of critical examination, and, like the Contextualists, he maintains that the environment exerts influence upon critical perceptions of a work of art.

Regarding the nature of art criticism, Lankford believes feelings are an integral part of critically experiencing art, referential and metaphorical elements of a work are significant, perceptual moments synthesize into a totally integrated experience of the work, no interpretation of the meaning of a work of art is absolute and eternal, phenomenological description as open-minded perception reveals the significance of a work of art, and verification of interpretations of works of art is a matter of agreement among subjective viewpoints. With respect to the outcomes of art criticism, Lankford believes that perceptual experience of art results in an increased aptitude for critical response to and appreciation of art and that critical experiences in art result in greater aptitude for encountering the world outside works of art.

Lankford's five part method of art criticism follows a phenomenological approach: Receptiveness, Orienting, Bracketing, Interpretive analysis, and Synthesis. The first component, Receptiveness, is an attempt by the viewers to free themselves of preconditions and habitual responses regarding the value and significance of a work of art or what a work means. Once receptivity is achieved, viewers initiate the second component, Orienting, which is intended to develop a communicative relationship with the work of art. Orienting requires viewers to pay attention to the effects of physical conditions surrounding the work of art, to determine the visual and spatial boundaries within which a work exists, and position one's body so that the work could be seen clearly and completely. Bracketing, a concept used extensively by Eugene Kaelin, is interpreted by Lankford to be a conscious act of concentrating and focusing upon the extant qualities of the object of art and limiting critical dialogue to content relevant to meanings communicated by the work. (Lankford, 1984)

The first three components, Receptiveness, Orienting, and Bracketing, are designed to achieve Husserl's pure aesthetic experience and Kaelin's relevance principle, empirical adequacy, and logical consistency, by limiting critical experiences to facts observed in works of art. This state of mind is believed

to result in an open and receptive orientation to meanings inherent in works of art. "The structures of the work of art as perceived must be placed in conscious brackets in order to insure relevant dialogue" (Lankford, 1984, p. 157). The fourth component, Interpretive analysis, is a discussion of the relationship of elements, representational and symbolic meanings, and "feelings controlled by these factors" (Lankford, 1984, p. 156). In actuality, this component is the core of his critical process. Synthesis, the final component, results in a judgment of the significance of the work as a whole. It is universal in that it extends the viewer's experience beyond what is exhibit in the work. Although value is formed out of the synthesis, no conclusion is absolute and judgment is made with caution.

Jim Cromer identified at least three kinds of art criticism that take place during instruction in art. He calls them in-process criticism, phase criticism, and closure criticism. All three are based upon linguistic rules of art and aesthetic experience and can be used in a discipline based approach to art education that includes the study of art production, art doctrines, art history, and art criticism. (Cromer, 1987) Cromer's approaches to criticism are based upon the principle that all people, regardless of training and experience in art and aesthetics, are capable of performing art criticism because they are innately skilled in linguistic rules of art and aesthetic experience. This principle has historic precedents in the work of Goethe, Wackenroder and Fiedler.

The linguistic rules of art and aesthetic experience, which are similar to Lev Vygotsky's (1969) basic laws of experience, are based upon (a) increasing and refining perceptual awareness and (b) transferring perceptual experience into symbols. Perceptual awareness is accentuated by the linguistic process of critically analyzing and interpreting what one sees. During the transformation of experience into symbols, thought operations are transferred from the plane of action to that of visual and verbal language. Symbolization of experience comes about through the manipulation of linguistic media for the purpose of inquiry, expression, and communication. These two kinds

of experience interact. Analysis and interpretation of perceptual data, which occur during the transfer of perceptual experience into symbols, increases perceptual awareness. This, in turn, results in the collection of an additional pool of raw data. And, an expansion of raw data, that results from growth in perceptual skills, becomes material for analysis and interpretation of perceptual experience and results in an increase in linguistic skills.

It can be demonstrated that the verbal interaction between student and teacher during the process of making art is a form of criticism that can impact upon the aesthetic quality of the student's work and his or her attitudes toward art. (Cromer, 1973) During in-process criticism, critical questions are asked that help students see what their work-in-progress communicates, develop their technical skills, and use art history information. In-process criticism begins with a discussion of the feelings being generated by the student's work and what is happening in the piece. The complexity of ideas gradually progress from a concrete level, in which observations unify into concepts, to an abstract level, in which these concepts are supported by empirical evidence.

Phase criticism is performed on works of art that are advanced but not finished, but are at various stages of development, works that require a sequence of steps for completion. The purpose of phase criticism is to help students understand the technical and conceptual directions their works are taking. The procedure for performing a phase critique is to respond to the aesthetic character of the work of art by discussing the feelings generated by the work and then identify technical, artistic, and aesthetic problems by describing what in the work caused them to have those feelings. Finally, students are assigned an artist to study who has worked on the same or similar problems. This makes art history more meaningful and gives students an opportunity to see how their problems were approached by mature artists.

Closure criticism is an aesthetic experience of perceiv-

ing, interpreting, understanding, and comprehending the expressive content of a finished work of art. Thinking in symbols is a fundamental thought process, motivated by the need to create, express, and communicate information, ideas, and knowledge. But most of all, art criticism implies social contact with other people. Based upon theories of John Dewey, that aesthetics is a part of ordinary experience and all people have prerequisite information and skills to be critical spectators of art, and the fact that no one lives in a social and cultural void, this view maintains that concepts that are pertinent in other social experience are aesthetic materials for the process of art criticism.

The Articulate Spectator Model of Art Criticism (ASMAC) is a linguistic approach to closure criticism, consisting of five complementary activities working together to form a unity: (a) aesthetic responding, (b) descriptive analyzing, (c) comparative analyzing, (d) interpreting, and (e) unifying. (Cromer, 1983) It is structured around the concept of openness as a receptivity to art based upon one's own personal experience. Rather than requiring advanced historical, technical, and theoretical knowledge and delimiting and bracketing the viewing of art, the ASMAC begins with the skills of viewing and interpreting that viewers already possess. Knowledge in art history, theory, and production are added during the natural course of performing art criticism. If artistic and aesthetic knowledge is a consequence of an intuitive, analytical, and interpretive experience with "reading" the content of a works of art, then it will have more meaning.

An overall aesthetic response reports the emotions and feelings that are being provoked by the work of art. Aesthetic responding involves spontaneous viewing of a work of art based upon a spectator's intuitive imagination. Aesthetic responding is pre-rational and pre-analytical perception of an object. Emotions and feelings, which have been activated by sentiments of past experiences, are translated into a verbal description of the aesthetic response. Spectators respond to the initial impact of color, space, and form in much the same way people

naturally make meaning out of all sensory experience. To elicit an aesthetic response from a view, simply ask, "How does this work of art make you feel?"

Descriptive analyzing begins the cognitive process of reasoning based upon the identification of formal elements of space, color, and design and the figurative elements that represent things and events. Elements are the "base morphemes" or units of language that are combined to create meaning. They are the aesthetic materials upon which the basic linguistic structure of visual arts rests. With experience and acquisition of technical, theoretical, and historical data, spectators will learn to identify even the smallest units of visual language that combine and interact to create an expressive work of art. To generate a descriptive analysis ask this question: What do you see in this work of art?

During comparative analysis, the spectator examines how elements and figures relate and determines what they have or do not have in common. The parts are synthesized into complex structures which are the "syntax " or combinations of base morphemes that support the interpretation of the ideas being communicated by the art object. To generate a comparative analysis ask this question: What is going on in this work of art?

Interpreting meaning involves the spectator in assigning importance and significance to a work of art. Meaning is derived out of the interaction of the aesthetic response with the combinations of elements that have been critically analyzed. Creating meaning out of subjective and objective responses is fundamental to all "semantics" and creates a world of phenomenal experience and knowledge. Interpretation is an existential, post analytic activity that results in an increase in critical intuition and direct perception. To generate an interpretation ask this question: What does this work of art mean to you?

Unifying is a process of integrating form and content into a harmonious and coherent whole. Being the culmination of

the metaphysical act of aesthetically responding to, examining, and interpreting the meaning of a work of art, the unifying statement can be used to compare the changes in feelings, ideas, and values that have taken place since the original aesthetic response was given at the beginning of the critique. This results in a growth in vivid and empathetic intuitions and an increase in the ability to derive meaning and pleasure out of works of art. To create a unifying statement that synthesizes all parts of the work into a whole, ask this question: What is this work of art about?

Throughout the history of aesthetics, artists, philosophers, historians, and critics have presented schemes that served as philosophical orientation to art and aesthetics. Philosophical schemes create different definitions of the nature of art as a reality, as knowledge, and as value. Historical schemes organize social and cultural information into stylized forms. Critical schemes give us processes for encountering, interpreting, and appreciating works of art. For curriculum in art education, schemes offer means for designing instruction that are drawn from developments in the fields of art and aesthetics. Part four presents sample units that illustrate the use of aesthetic schemes for structuring curricula in art.

PART FOUR

Sample Units

Late in the 1950's, the child-centered approach to art education had begun to realize its goal of developing curricula that promoted creative and mental growth in our youth. Attention was then focused upon the importance of complementing this with artistic and aesthetic growth as well. Because most art education programs were oriented to production of art, this new interest in the subject matter of art became what David Ecker (1970) called "the aesthetic education movement" (p. 51). As early as 1962, Manuel Barkan had set the parameters for this movement by writing that a subject matter or discipline of art existed and that it should be taught, that this subject matter was produced and demonstrated by people who were practitioners of art, and that a similarity exists between learning in art and learning in verbal language. (Barkan, 1962, p. 18)

Schematization of approaches to art and aesthetics is part of the process of identifying subject matter and unifying areas of study. Throughout history, participants in art and aesthetics used schematization to identify areas of content and distinguish the commonalities upon which they could be combined into an integrated subject matter. This is true for contemporary art education. Both Harry S. Broudy (1961) and Charles Dorn (1981) have called for the need of a theory to integrate the subject matter of art and aesthetics.

Many theories exist from which we can design and implement art and aesthetic curricula. Feldman believed that a social theory of art existed. He also promoted a theory of critical skills. Pepper promoted a theory of taste and both Feldman and Pepper believed in a theory of aesthetic pleasure. Other theories have been centered around anthropology, developing intuition, connoisseurship, artistic personality, artistic consciousness, forming world views, art appreciation, basic skills, visual language skills, expression, and visual literacy. Many of these will inadvertently be taught and learned regardless of the approach one might take. However, the approach I find to be most constructive is that making, viewing, interpreting, and studying art are linguistic processes. Within this model, the subject-matter of art education would promote the acquisition of visual language skills, the appreciation of great works of visual arts, and the comprehension of fundamental art doctrines.

Four sample units are presented below. They are based on parallel aesthetic schemes in art doctrine, art history, and art criticism (see Aesthetic schemes chart). They are subject-matter oriented and designed around the concept of art as a visual language.

Unit One: Emotional Responding

Aesthetic Responding Schemes

One of the greatest benefits of the study of art is in dealing with emotions and feelings. This unit uses the Aesthetic Responding Schemes of Sensism, Romanticism, and Mechanism to provide young people with a therapeutic opportunity to study their own and others' subjective responses to the world and to express their feelings within a creative and constructive environment. The sensory approach of the art doctrine, Sensism, explores sentiments, emotions, and feelings. Through

the study of Sensism, students acquire a pre-rational, pre-symbolic, and autonomous contemplation and learn to intuitively respond to aesthetic information found within existential experience. They increase their pure visibility, which is a direct and subjective awareness of the significance of aesthetic encounters.

The historical study of Romanticism teaches stylistic techniques for expressing feelings and emotions through art. Students learn that affective behavior is a natural and vital element in the formation of personal and cultural values. Romanticists enhance emotion through the use of brilliant colors, gestural form, and ambiguity of space. Solid forms dissolve and shadows are shown in full color. Details are obscured in order to represent an inner feeling at a given moment in time. Although surfaces appear to be fluid, the subject matter and content are existentially etched in our minds. Visual properties are dynamically naturalistic and impressionistic. Romanticists portray not what can be seen but what can be expressed about experience and distort rather than imitate nature. Their treatment of form shows a concern for humanistic situations during various ages of anxiety.

The critical techniques of Mechanism reveal pleasure as a motive for aesthetic responding. They are based within physical time and space and upon the ability of the spectator to have an existential experience. Although viewers respond to phenomenal experience rather than art objects alone, inner feelings and emotions are expressed within the aesthetic materials of the external object. The linguistic structure of experience, formed out of the interaction of associations between inner feelings and external experience, increases the spectator's capacity for enjoyment in art.

Activities and Sequence of Unit

Scope of the Unit

Art production, art doctrine, art history, and art criticism activities are described in this section in order that the content of each activity can be presented.

Art Doctrine

The content of activities in art doctrine is philosophic ideas about the nature of art.

Therapeutic value. Discuss the therapeutic value of exploring and expressing inner feelings.

Emotional content of Romantic pictures. Examine the emotional content of Romantic pictures by determining if they are calm or exciting. Select the excited shots and have students identify the sense impression and emotions they are feeling. Write these down and see how many others in the class are having the same impressions.

Discuss the nature of expression. Have students discuss the nature of expression, what inner feelings look like, and how distorting nature rather than imitating it contributes to expressiveness.

Discuss the quetion of what is real. Discuss the difference between reality being the material substance of the world in contrast to it being the inner feelings that are expressed through objects. Explore the existence of thinking that is pre-rational, pre-symbolic, and autonomous contemplation by having students listen to music, let their minds "wander," and experience a pure visibility that excludes thinking in words.

Moment of time. Students will study the existential concept of a "moment of time" by identifying pictures that are full of artistic movement but appear to be frozen in time and space. Discuss what effects this has on the content of the work and research how far back into history this approach goes.

Modification of visual form. The modification of visual form for the purpose of enhancing aesthetic content is one of our oldest techniques of language. Have students study photographs of objects to determine why and how artist distorted them in their works of art.

Art History

The content of activities in art history is the interaction of art and society.

Presentation on Romantic art. Show a presentation on Romantic art throughout history. Be sure to include the Late Classical art of Greece, the Proto-Baroque work of Titian, the Romantic paintings of Peter Paul Rubens, Theodore Gericault, and Eugene Delacroix, the moving surface of Auguste Renoir, the dynamic and immediate "impression" of Edgar Degas, the emotional symbolism of Vincent Van Gogh, and the gestures of Jackson Pollock and Willem de Kooning. Have students research romantic artists whose work expresses feelings and emotions and do an historical timeline of social conditions that contributed to these works.

Delacroix and Gericault. Have students research styles of Delacroix and Gericault. What kind of subject matter did they choose? What kind of psychological make up caused artists to use a Romantic style? Vincent Van Gogh is the epitome of a Romantic artist. Study the events in Van Gogh's life and how these contributed to his Romantic style. Study his writings, the idea that art is therapeutic, and whether or not it helped Van Gogh.

Moment in time. Romantic artists' works often contain a feeling that they portray a moment in time, that they are frozen in space and that they are an impression of reality. Research how far back into history this approach goes. When were the first works created that demonstrate this technique?

Art Criticism

The content of activities in art criticism is the critical viewing and interpreting of meaning in art.

Moment in time. Critique a Romantic work of art and concentrate on increasing your sensitivity to a moment in time.

Critique of a Romantic work. Perform a critique of a Romantic work, comparing the emotions and feelings identified during the early stages of aesthetic responding with interpretations about what is being expressed, which are concluded at the end of the critique. During the analysis, determine what forms are interacting to make up the syntax of the visual expression of feelings. Discuss whether or not the critique was therapeutic and what was learned about feelings.

Describe events in your life. During a critique of a Romantic work of art, describe events in your life that remind you of the Romantic work.

Better understand the events. Critique your final work of art and discuss how you better understand the events.

Modern work of Romantic art. Do a critique of a modern work of Romantic art and discuss what in modern times causes these kinds of feelings to be generated.

Art Production

The content of activities in art production is the techniques of expressing feelings through an aesthetic object.

Forms of objects are cut off. Do a work of art in which the forms of objects are cut off at the edge, therefore implying that the work continues beyond the borders of the canvas or paper and shows infinite environmental space.

Blow it up into a larger work. Draw gestural sketches with a brush and paint. Select one that you like and blow it up into a larger work. Do this by using a grid technique or an opaque projector.

Written account of events in your life. Use the written account of events in your life that were stimulated by a critique of a Romantic work of art to do a work of art. To select your colors, take your paints out of doors and view them in sunlight. Paint in a technique that eliminates finer details and boundaries between objects and concentrate on the interaction of colors. Emphasize a moving fluid surface that is dancing with light but create forms that are frozen in space.

Sequence of Lessons

The sequence of activities is described in this section and demonstrates how activities interact for greater learning effects.

Historical presentation of Romantic art. Show the historical presentation of Romantic art and works that express feelings. Do the historic timeline of social conditions that contributed to these works.

Discuss the nature of expression. Discuss what inner feelings look like, and how distortion of nature contributes to expressiveness.

Modification of visual form. Study the modification of visual form for the purpose of enhancing aesthetic content by using critical techniques to examine how photographs of objects compare to the way artist have distorted them in their works of art.

Critique a Romantic work. Compare emotions and feelings identified before and after the analysis and interpretation. Discuss whether or not the critique was therapeutic and what was learned about feelings.

Description of events in your life. Write a description of events in your life that remind you of the Romantic work that was just critiqued.

Blow it up into a larger work. Draw gestural and impressionistic sketches of the events with a brush and paint and blow them up into larger works. Create a finished work of art and do a closure critique.

Delacroix and Gericault. Research styles and subject matter of Delacroix and Gericault. Discuss the psychological make-up of Romantic artists, such as Van Gogh, and events that contribute to Romantic style. Discuss the notion of art being therapeutic.

Modern work of Romantic art. Critique a modern work of Romantic art and discuss what in modern times causes these kinds of feelings to be generated.

Emotional content Romantic pictures. Critique the emotional content of Romantic pictures, write down sense impression, and compare them with the impressions of other students in the class.

Discuss the notion of what is real. Discuss inner feelings expressed through objects. Have students listen to music and let their minds "wander" and experience a pure visibility that excludes thinking in words.

Moment of time. Study the existential concept of a "moment of time" by critiquing pictures that are full of artistic movement but appear to be frozen in time and space.

Forms of object are cut off. Do a work of art in which the forms of objects are cut off at the edge to imply infinite space.

Written account of events in your life. Use the written account of events in your life that were stimulated by a critique of a Romantic work of art and do a final work of art.

Better understand the events. Critique your final work of art and discuss how you better understand the events depicted.

Unit Two:
Balance of Emotion and Restraint

Analytic Schemes

Another positive outcome of the study of art is the acquisition of critical and analytical skills. This unit uses the Analytic Schemes of Formism, Classicism, and Formalism to give students an opportunity to develop skills of describing and comparing elements of a visual field. The art doctrine of Formism held that rationalism was obtained through objectivity. Reality was constructed out of the physical relationship of elements of the environment that fund into universal qualities and distinct ideas. This rational approach to cognition transcends sensory experience giving us an abstracted and explicit view of reality.

The historical study of Classicism reveals a search for factual truths that represent an ideal made visible through abstracted forms and symbols. Beauty is found through rational idealism and external comprehension. Classicism balances

71

emotion and restraint through a linear, geometric, and symmetrical composition that is technically controlled. Instead of just grasping what is of the moment, Classicism captures what the moment can be. It is future oriented in the same way Plato believed that the world was evolving into an idealized form.

The critical scheme of Formalism applies aesthetic materials to universal norms by representing and imitating intellectual and universal ideas as a basis for aesthetic values, concentrating on achieving physical and technical perfection of objects, and associating universal ideas with cultural norms that are expressions of a period in time. The intellectual norm is found outside human experience but within human representations. Through the Formalistic analysis of factual aesthetic materials of a work of art, intellectual, physical, and cultural norms can be experienced.

Activities and Sequence of Unit

Scope of the Unit

Art doctrine, art history, art criticism, and art production activities are described in this section of the unit in order that the content of each activity can be presented.

Art Doctrine

The content of activities in art doctrine is philosophic ideas about the nature of art.

Basic concepts of Classicism. Have students study the basic concepts of Classicism, such as universal norms, objective truth, rationalism as a means of acquiring facts, and the superiority of reasoning over emotions. After students have studied and discussed these ideas, have them look for evidence of these approaches in society as a whole.

Relationship of science to art. Both science and art explore and communicate ideas about natural and man-make environments. A relationship between science and art dates back to antiquity. Have students study the relationship of science to art, especially Classicism.

Social conditions. Classicism has competed continually with Romanticism from Greek Antiquity through modern art. Have students study social conditions in society that cause art to swing from Romantic to Classical approaches to art.

Art History

The content of activities in art history is the interaction of art and society.

Presentations on Classical art. Do an historical presentation on Classical art throughout history and have students identify examples that they find appealing.

Kind of political messages. Jacques-Louis David, one of the greatest artists to paint in a Classical style, used his work to promote political idealism during the French Revolution, especially patriotism and courage. Study the work of Classical artists to determine what kind of political messages this style promotes and how effective it has been socially. Do we see evidence of these techniques being used today on television?

Student of Jacques-Louis David. Even though Jean-Auguste Dominique Ingres, another Classicist, was a student of Jacques-Louis David, he used a different style. Study the personal and cultural history of Classical artists to determine what psychological factors influenced their views toward Classicism.

Georges Seurat's scientific Pointillism. Seurat's juxtaposition of small brushstrokes of color to create a uniform surface and his symmetrical compositions were scientifically

controlled. His color, Pointillism, was also scientific, in that pure dabs of color were optically mixed. Also, Seurat used the color studies of scientists Hermann von Helmholtz and Michel-Eugene Chevreul. Have students study how scientific technology has influenced art, and vice versa, throughout the history of art.

Examples of Classical art. Classicism spans the breadth of history from early art of Antiquity to Modern art. Following the presentation on Classicism, have students identify a sequence of examples of Classical art from early forms through the most recent examples.

Art Criticism

The content of activities in art criticism is the critical viewing and interpreting of meaning in art.

Critique a contemporary magazine picture. Find a contemporary magazine picture that contains Classical elements. Critique the picture to identify Classical ideas. Do a series of sketches that progressively simplifies the composition into a Modern classical style of restrained form. At each stage of abstraction, do an analysis to see if the Classical ideas are still in the work. The goal is to minimize and simplify the form in order to reveal pure and universal ideas.

Critique a primitive work. Primitivism has had a major influence on Modern art. Have students critique a primitive work for Classical techniques and ideas. Then analyze various examples of art in modern times to determine how primitive classical techniques have been used in contemporary styles. An example can be seen in the integration of primitive art and Analytic Cubism of Pablo Picasso.

Analyze the physical relationship of the work of David and Ingres. Jean-Auguste Dominique Ingres and Jacques-Louis David were exemplary Neo-Classicists. Ingres used an

abstracted line rather than planar space and explored more exotic subjects than David. Using critical techniques of Formalism, analyze the physical relationship of the work of David and Ingres for universal norms they both promoted, individual ideas they each expressed in their art, and ways in which their techniques differed.

Art Production

The content of activities in art production is the techniques of expressing feelings through an aesthetic object.

Sketches from a contemporary magazine picture. Following the criticism sequence in which a contemporary magazine picture that contains Classical elements is analyzed and abstracted, have students use the sketches to create a final work of art.

Abstract Expressionism. Abstract Expressionism had a Classical and Romantic side. Romantic Abstract Expressionism relied upon gestural forms of Action Painting while Classical Abstract Expressionism relied upon subdued compositions of Color Field paintings that played down the brushstroke and increased the size of the works so that the viewer would be overwhelmed with Classical content. Have students produce a large work of art using variations of Color Field techniques.

Cubist grid. The Cubist grid arranged works into structural lines that balanced the delicate texturing of the forms. Eventually, realistic effects were added to these works by actually including found "ready made" objects such as cloth, newspapers, wallpaper, etc. in the composition. Do a work that explores the Cubist grid and add found materials to the composition. Study the question "What is reality, what is illusion, and what is conceptual in painting?"

Study of the influences of Primitivism on Classical techniques. Following the critical study of the influences of Primitivism on Classical techniques in Modern art, such as the integration of primitive art and Analytic Cubism of Pablo Picasso, have students do visual studies of Primitive art, Neo-Classicism, and Modern art. Do a work of art that contains all three Classical styles; Primitivism, Neo Classicism, and Modern. Choose a modern topic, perhaps from film, television, or photography, that is compatible with the Classical doctrine.

Alternative styles. The Classical surface has developed alternative styles to maintain a balance between emotionalism and intellectualism. Some are abstractly flattened spaces, tight patterned surfaces, shifting and collapsing geometric surfaces, and indistinct foreground and background relationships. Have students study and experiment with each of these treatments of Classical space and select one to explore in depth in a final work of art

Political ideal. Classicism has had a history of being used for political purposes. Choose a political ideal and do a work in Classical style that portrays the ideal in an appealing way. Concentrate on simplification to drive the powerful message home to the viewer.

Sequence of Lessons

The sequence of activities is described in this section and demonstrates how activities interact for greater learning effects.

Presentation on Classical art. Do an historical presentation on Classical art throughout history and have students point out examples that they find appealing.

Examples of Classical art. Have students collect a sequence of examples of Classical art from early forms through the most recent examples.

Basic Classical concepts. Study the basic Classical concepts of universal norms, objective truth, rationalism as a means of acquiring facts, and the superiority of reasoning over emotions.

Critique a contemporary magazine picture. Critique a contemporary magazine picture for Classical elements and do a series of sketches and critiques that simplify the composition into a Modern Classical style of restrained form. Do a phase critique on series.

Sketches from a contemporary magazine picture. Following the critique of a contemporary magazine picture, have students use the sketches to create a final work of art.

Social conditions. Do an analysis of social conditions that cause art to swing from Romantic to Classical approaches to art.

Abstract Expressionism. Have student study the Classical and Romantic sides of Abstract Expressionism and have students produce a work that demonstrates each style.

Analyze the physical relationship of the work of David and Ingres. Using critical techniques of Formalism, analyze the physical relationship of the work of David and Ingres for universal norms they both promoted, individual ideas they each expressed in their art, and ways in which their techniques differed.

Student of Jacques-Louis David. Jean-Auguste Dominique Ingres was a student of Jacques-Louis David. Study the personal and cultural history of Classical artists to determine what psychological factors influenced their views toward Classicism.

Alternative styles. Have students study and experiment with alternative styles of Classicism and select one to explore in depth in a final work of art.

Critique a primitive work. Have students critique a primitive work for Classical techniques and ideas and then analyze various examples of twentieth century art to determine how primitive classical techniques have been used in contemporary styles.

Study of the influences of Primitivism on Classical techniques. Following the critical study of the influences of Primitivism on Classical techniques, use modern photography to do a work of art that contains elements of Primitive, Neo-Classicism, and Modern Classicism.

Relationship of science to art. Have students study the historical relationship of science to art, especially in Classicism, and the influence of scientific technology on art and artistic technology on science.

Georges Seurat's scientific Pointillism. Have students do a work of art in which they study Georges Seurat's scientific Pointillism.

Cubist grid. Do a work that explores the Cubist grid and add found objects and materials to the composition. Study the question "What is reality, what is illusion, and what is conceptual in painting?"

Kind of political messages. Study the work of Classical artists to determine what kind of political messages this style promotes and how effective it has been socially. Where do we see evidence of these techniques being used today on television?

Political ideal. Choose a political ideal and do a work in Classical style that portrays the ideal in an appealing and forceful way.

Unit Three:
Study of Interaction in Art

Interpretive Schemes

Through the study of the Interpretive Schemes of Syncretism, Hellenism, and Contextualism, students are taught the skills of integrating opposites by interpreting how they interact to produce a expanded view of reality. The art doctrine of Syncretism also dates back to Greek culture. In order to solve the contradictions between Classicism and Romanticism, critics became interested in the interactive aesthetics of rectifying opposites, paradoxes, and antinomies. They believed that opposites existed within art for the purpose of amplifying each other. Just as an object is defined by its action, the nature of action is shaped by the relativity and context of the objects involved. In synthesizing the objective truth with the subjective ideal, mankind could inquire into and express realities that transcended sensory experience. Synthesizing opposites was possible because of the capacity of art and aesthetics to linguistically create meaning out the interaction of subjective and objective materials. For the spectators, post-analytical interpretation of art revealed both external and internal worlds of experience.

An historical examination of Syncretism indicated that the integration of opposing forces in art and aesthetics had been going on since Greek Hellenistic art. Syncretism was characterized by excessive, theatrical emotionalism and a use of illusion to heighten realism. But, amid the emotionalism was simplicity and idealism. It was balanced between harsh emotionalism and serene symbolism. For example, Gauguin's Synthetism balanced unnatural colors with symbolic forms. And Matisse insisted on a complement of expression and restraint. Syncretic art showed us a natural push and pull of opposites and in extending the viewing space beyond the object, it diminished the separation between art and reality.

The critical scheme of Contextualism concentrated upon interpreting the significance of the whole of an aesthetic environment by understanding the syntactical connectivity of elements of art. The aesthetic experience was made vivid and intense by integrating elements of conflict throughout the piece and using psychic distance to control the resulting emotionalism. Social issues were accentuated and the language of art made the viewer graphically aware of the details of social conflict. Interpretation of content was verified through evidence taken from a social and cultural context. Ultimately, as viewers work their way toward a unified understanding of the whole of the work, content is transformed into a refined and critically intuitive but unanalyzed spirit, and the object of art becomes a cultural artifact.

Activities and Sequence of Unit

Scope of the Unit

Art doctrine, art history, art criticism, and art production activities are described in this section of the unit in order that the content of each activity can be presented.

Art Doctrine

The content of activities in art doctrine is philosophic ideas about the nature of art.

Synthetic Cubist artists. Picasso and Braque glued bits of newspapers, magazines, wallpaper, rope, bottle labels, to their paintings and drawings to create Synthetic Cubist collages. Show examples and discuss this as a Syncretic integration of art with reality.

Show work of Henri Matisse. Show Matisse's "The Red Room" and discuss how patterns make the viewer feel the flatness of the canvas while still retaining an atmosphere of three

dimensional space. This resulted in an ambiguity, and the space between reality and illusion was diminished.

Opposites exist within art. Discuss the philosophical idea that opposites exist within art for the purpose of amplifying each other and that an object is defined by its action and the nature of action is shaped by the relativity and context of the objects involved.

Show work of Gauguin. Show Gauguin's "Jacob Wrestling with the Angel," and discuss his technique, called Synthetism, in which he integrates broad areas of unnatural colors and symbolic forms.

Art History

The content of activities in art history is the interaction of art and society.

Present a chronological overview. Present an overview of Syncretic art, such as Hellenistic art, Mannerism, the Syntheticism of Gauguin, Matisse, the Synthetic Cubism of Picasso, Abstract Expressionism, Pop Art, and Photorealism. Emphasize the cultural contexts for each of these movements.

Influence of Pop art on Photorealism. Have students study the influence of Pop art on Photorealism, especially in the work of Audrey Flack, Richard Estes, Chuck Close, and Ralph Goings. Have them concentrate on the Syncretic nature of Photorealism as an integration of something old and new.

Work of Robert Rauschenberg and Jasper Johns. Have students study the work of Robert Rauschenberg and Jasper Johns as examples of the integration of the techniques of Abstract Expressionist and Color Field painting. Then study the technique of Pop artists in which their art exists somewhere between real life and art because they incorporate common and popular images.

Invention of Collage art. Do a presentation on the invention of Collage art and the beginning of Synthetic Cubism as examples of Syncretic art.

European and American social contexts. European and American societies were integrated through art because of the many European artists who moved to America during World War I. Study the effects this had on artists such as Roy Lichtenstein, James Rosenquist, Tom Wesselmann, Larry Rivers, Andy Warhol, Morris Louis, Helen Frankenthaler, Christo, Louise Nevelson, Robert Motherwell, Judy Pfaff, etc.

Process of thesis, antithesis, and synthesis. In science, knowledge is developed out of a process of thesis, antithesis, and synthesis. Investigate the relationship of this scientific process with the parallel art movements of Romanticism, Classicism, and Syncretism. Discuss how they are related culturally.

Art Criticism

The content of activities in art criticism is the critical viewing and interpreting of meaning in art.

Select an image. Chose an image, such as television, film, posters, political advertisement, photographs, etc., from a social context and critique it for content.

Examples of Syncretism. Following a presentation of instances of syncretism, select art works that are examples of Syncretism and critique them in order to identify sameness and differences and the effects of integration on meaning and content.

Push and pull. Syncretic artists, who integrated Romanticism and Classicism, were exploring push and pull as symbolic of nature. Have students analyze pictures of nature in order

to identify other abstract concept that they can explore in abstract art.

Integration of art and reality. Perform a critique to interpret what is being expressed by the integration of art and reality in synthetic cubism.

Pure color. Many Syncretic artists painted pure color in order to make the aesthetic experience a vivid and intense form of realism. Have students critically study these works in order to interpret why subtleties of color were enhanced.

Balance of two and three dimensional space. Do a closure critique to determine how this balance of two and three dimensional space affects the interpretation of content.

Art Production

The content of activities in art production is the technique of expressing feelings through an aesthetic object.

Cut several geometric shapes. Have students cut several geometric shapes out of photographs, newspapers, wallpaper, decorative papers, etc. and construct a collage that expresses the reality of the content identified through the above critiques.

Collage as a design. Use the collage as a design for a painting. An example of this would be Picasso's *Guernica*, about the German bombing of the Basque town of Guernica.

Three basic techniques. Photorealism uses three basic techniques: a modern version of the camera obscura (a slide projector) for tracing images on a canvas or paper, the old Greek grid technique, and photographically transferred images. Experiment with all three, choose the one most appealing, and create a realistic work of art. Explore illusion and reality by giving attention to surface qualities of objects and the way light creates a textured surface, classical single point perspective,

the theatrical drama of reflections in bright shiny surfaces, and multiple images in found reflections.

Combine paintings. Have students do Pop Art technique of making combine paintings in which real objects from society are integrated with expressionistic gestural brush strokes in order to synthesize reality with art. Look at the work of Roy Lichtenstein, James Rosenquist, Tom Wesselmann, Larry Rivers, Andy Warhol, Morris Louis, Helen Frankenthaler, Christo, Louise Nevelson, Robert Motherwell, Judy Pfaff, etc.

Enlarging a detail. Study the push and pull concept of abstract art by enlarging a detail of a photograph.

Color is used. Produce a work in which color is used to create flat two dimensional space but lines are used to create three dimensions.

Trace a photograph. Have students trace a photograph. Make the room dark or blindfold them so their eyes will be more sensitive to subtle colors. Then look at a photograph for even the hint of colors and label the tracing with what colors they see. Then do an original work of art that uses the color scheme worked out in the tracing.

Sequence of Lessons

The sequence of activities is described in this section and demonstrates how activities interact for greater learning effects.

Present a chronological overview. Show examples of Syncretism, and emphasize the cultural contexts for each of these movements.

Opposites exist within art. Discuss the philosophic idea that opposites exist within art for the purpose of amplifying each other.

Process of antithesis, and synthesis. Investigate the relationship of the scientific process of thesis, antithesis, and synthesis to art movements of Romanticism, Classicism, and Syncretism.

Examples of Syncretism. Select art works that are examples of Syncretism and critique them in order to identify the effects of integration on meaning and intent.

Show work of Gauguin. Show Gauguin's "Jacob Wrestling with the Angel," and discuss his integration of broad areas of unnatural colors and symbolic forms.

Pure color. Many Syncretic artists painted pure color. Have students critically study these Syncretic works in order to determine the effects of pure color on content.

Trace a photograph. Have students trace a photograph, then do an original work of art that uses the subtle scheme of colors worked out in the tracing.

Show work of Henri Matisse. Show Matisse's use of ambiguous space to work between reality and illusion.

Balance of two and three dimensional space. Do a closure critique of Matisse's work to determine how his balance of two and three dimensional space affects the interpretation of content.

Color is used. Produce a work in which color is used to create flat two dimensional space but lines are used to create three dimensions.
Invention of Collage art. Do a presentation on the invention of Collage art and the beginning of Synthetic Cubism as examples of Syncretic art.

Synthetic Cubist artists. Cubist artists glued materials to their paintings and drawings. Show examples of Cubistic

collages and discuss this as a Syncretic integration of art with reality.

Integration of art and reality. Perform a critique to interpret what is being expressed by the integration of art and reality in synthetic cubism.

Cut several geometric shapes. Have students cut several geometric shapes and construct a collage.

Collage as a design. Use the collage as a design for a painting.

Push and pull. Syncretic artists were exploring push and pull as symbolic of nature. Have students analyze pictures of nature in order to identify push and pull and other abstract concepts.

Enlarging a detail. Study the push and pull concept of abstract art by enlarging a detail of a photograph.

European and American social contexts. European and American societies were integrated through art because of the many European artists who moved to America during World War One. Study the effects this had on abstract expressionist art.

Work of Robert Rauschenberg and Jasper Johns. Have students study works of Robert Rauschenberg and Jasper Johns that are believed to exist somewhere between real life and art because of their common and popular images.

Combine paintings. Have students make combine paintings in which real objects are integrated with expressionistic gestural brush strokes in order to synthesize reality with art.

Influence of Pop art on Photorealism. Have students study the influence of Pop art on Photorealism and concentrate on the integration of something old and new.

Select an image. Chose an image from a social context and critique it for content.

Three basic techniques. Photorealism uses three basic techniques. Experiment with all three and create a realist work of art.

Unit Four: Transcending Nature

Unifying Schemes

A study of the Unifying Schemes of Voluntarism, Medievalism, and Organicism develops the spontaneous and creative imagination necessary to transcend nature and the free and empathic Will needed to see infinite possibilities. In contemporary times, this has led to the use of art imagery as entertainment, a view of supernatural worlds, an experience of our spirituality, and as dreams about fantastic and futuristic worlds. The art doctrine of Voluntarism promoted the concept of the empathetic Will, but also the need for it to be controlled by concepts of good. Good was rewarded by feelings of pleasure and ecstasy. This situation has been a major influence in the use of criticism to pass judgment on works of art. Free and spontaneous Will allowed viewers to transcend the materialistic, physical, emotional, and intellectual worlds for an infinite world of the spirit.

Medieval art history marks the beginning of art that transports the viewer from the earth-bound realism of the everyday world into a universal and organismic expression of mind. The free imagination of schemes of unification found fulfillment in abstract, decorative, and symbolic fantasy worlds of twentieth century art. Ordinary objects were put into extraordinary situations. The haunting sense of reality created an uncertainty between perception and imagination. It was a super realism that went beyond everyday reality. Carried to it

fullest, it abandoned objects altogether and became the first instance of an abstract art that was free from the shackles of observable reality. Dynamic and decorative forms represent a "stream of consciousness." Free association became the basis for a new objectivity and a fantastic representation of the limitless mind.

The critical approach of Organicism has as its main concerns the structure of a work, the integration of parts into coherent ideas and concepts, and the pleasure of working from the connections of elements of an aesthetic experience to an ultimate unity. The integration of intuitions and emotions, of evidence and facts, of interpretations and qualitative perceptions results in the recreation of a universal mind.

Activities and Sequence of Unit

Scope of the Unit

Art doctrine, art history, art criticism, and art production activities are described in this section of the unit in order that the content of each activity can be presented.

Art Doctrine

The content of activities in art doctrine is philosophic ideas about the nature of art.

Abstracted forms and pure colors. Discuss the doctrine that abstracted forms and pure colors which abandon concrete and observable reality altogether can still carry meaning and content.

Wassily Kandinsky. Research and discuss the Russian artist Wassily Kandinsky's (1866-1944) ideas on spirituality in art, the ability of color to communicate psychological concerns, and the expressive power of painting itself.

Examples of fantastic imagery Phantastikos is Greek for "Fantastic", which is a representation of the mind. Have students bring to class examples of fantastic imagery that illustrate realities of the mind.

Art History

The content of activities in art history is the interaction of art and society.

Birth of non-objective art. Do a presentation on the birth of non-objective art and the work of Wassily Kandinsky. Show the transition of his work from realism into purely abstract art.

New Objectivity. What in society caused artists to retreat from realism and art that was based upon referential subject matter? Have students study the early twentieth century to see how art and society interacted to create the need for free association and art of The New Objectivity.

Surrealism. Fantastic art is the representation of incredible images of the artist's mind, and prior to the twentieth century there were some examples of fantastic art in Hieronymus Bosch and Odion Redon. Do a presentation on works of art that eventually led to Surrealism.

Art Criticism

The content of activities in art criticism is the critical viewing and interpreting of meaning in art.

Irrelevant elements. At each stage in the development of Kandinsky's work, perform a critique to identify irrelevant elements and determine what unified concepts are carried into his non-objective art.

Details of images. Have students use critical techniques to describe images that they "see," through free association, in a textured surface. This will help them form the work into an organismic whole.

Metaphysical and spiritual concepts. Have students do a closure critique of an example of fantastic art, then a second critique of an image they bring to class, and then do a comparison of the two for metaphysical and spiritual concepts.

Phase critique on the Surrealistic collage. Do a phase critique on the Surrealistic collage to comprehend feelings it is generating, to identify aesthetic and art problems being explored, and to study approaches to solving problems that have been achieved in the past.

Art Production

The content of activities in art production is the techniques of expressing feelings through an aesthetic object.

Gradually abstract elements out. Do a work of art by selecting a photograph from a magazine and producing sketches that gradually abstract elements out that are non essential to the overall unity of expression. Use the last sketch as a design for a final work of art.

Through free association, "see" objects and events. Stream of consciousness and free association are techniques of Voluntarism which allow artists to create a spontaneous interaction of their own aesthetic reactions with the expressive power of painting itself. Do a work of art in which a surface is textured. Have students study the image and through free

association, "see" objects and events that are taking place in the work. Have them draw and paint what they see into the textured surface.

Create a Surrealistic collage. Using examples of fantastic art, cut up shapes, colors, and textures, and create a Surrealistic collage.

Final work of art. Using the Surrealistic collage and phase critique, do a final work of art.

Sequence of Lessons

The sequence of activities is described in this section and demonstrates how activities interact for greater learning effects.

Birth of non-objective art. Do a presentation on the birth of non-objective art and the work of Wassily Kandinsky.

Abstracted forms and pure colors. Discuss how abstracted forms and pure colors, which abandon concrete and observable reality altogether, can carry meaning and content.

Irrelevant elements. At each stage in the development of Kandinsky's work, perform a critique to identify irrelevant elements.

Gradually abstract elements out. Select a photograph from a magazine and produce sketches that gradually abstract elements out that are nonessential. Use the last sketch as a design for a final work of art.

Wassily Kandinsky Research and discuss Russian artist Wassily Kandinsky's (1866-1944) ideas on spirituality in art.

Through free association, "see" objects and events. Do a work of art in which a surface is textured. Have students study the image and, through free association, "see" objects and

events that are taking place in the work. Have them draw and paint what they see into the textured surface.

Details of images. Have students use critical techniques to describe images that they "see" in a textured surface.

New Objectivity. Have students study the early twentieth century to see how art and society interacted to create the need for free association and art of The New Objectivity.

Examples of fantastic imagery. Have students bring to class examples of fantastic imagery that illustrate realities of the mind.

Surrealism. Do a presentation on works of art that eventually led to Surrealism.

Metaphysical and spiritual concepts. Have students do a closure critique of fantastic art and then an image they brought to class. Compare the two for metaphysical and spiritual concepts.

Create a Surrealistic collage. Using examples of fantastic art, cut up shapes, colors, and textures, and create a Surrealistic collage.

Phase critique on the Surrealistic collage. Do a phase critique on the Surrealistic collage to comprehend feelings it is generating, to identify aesthetic and art problems being explored, and to study approaches to solving problems that have been achieved in the past.

Final work of art. Using the Surrealistic collage and phase critique, do a final work of art.

REFERENCES

Broudy, H. S. (1972). *Enlightened cherishing.* Illinois: University of Illinois Press.

Broudy, Harry S. (1964). The structure of knowledge in the arts. In S. Elam (Ed.), *Fifth annual Phi Delta Kappa symposium on education research.* Chicago: Rand McNally and Company.

Broudy, H. S. (1961). *Building a philosophy of education.* Englewood Cliffs: Prentice Hall, Inc.

Cromer, J. L. (1973). Verbal language conditions as a determinant of aesthetic performances. *Studies in Art Education, 15,*(1), 49-60).

Cromer, J. L. (1977). Art criticism: Learning to see through talking about art. *South Carolina Art Education Association (SCAEA) Conference.* Charleston, South Carolina, October 15.

Cromer, J.L. (1987). Art Criticism and Visual Literacy. *School Arts,* April, 1987.

Carritt, E. F. (1951). *An introduction to aesthetics.* New York: Hutchinson's University Library.

Dewey, J. (1938). *Experience and education.* New York: Collier Books.

Dorn, C. (1981). Separate but not equal: The unfulfilled promise of art curriculum. *Art Education, Journal of the National Art Education Association, 34*(6), 28-33.

Duchamp, M. (1957). The creative act. In G. Battcock, (Ed.). (1966). *The new art: A critical anthology.* New York: E. P. Dutton

Ecker, David, Hausman, J., Sandler, I. (1970). *Conference on art criticism and art education.* New York: New York University Press.

Feldman, E. (1970). *Becoming human through art.* Englewood Cliffs, New Jersey: Prentice Hall.

Feldman, E. (1985). *Varieties of visual experience.* Englewood Cliffs, New Jersey: Prentice-Hall.

Feldman, E., (March, 1968). Some adventures in art criticism. *Art Education: Journal of the National Art Education Association, 22*(3), 24-28.

Fichner-Rathus, Lois (1986). *Understanding art.* Englewood Cliffs, New Jersey: Prentice-Hall.

Getty Center for Education in Arts, (1885) *Beyond Creating: The Place for Art in America's Schools* (Research report of the Rand Corporation, Publicaton Department, Santa Monica, California.)

Kaelin, Eugene F. (1968). An existential-phenomenological account of aesthetic education. *Penn State Papers in Art Education,* No. 4.

Lankford, L. E. (1984). A phenomenological methodology for art criticism. *Studies in Art Education, 25,* (3), 151-158.

Lee, Otis, (1944). Value and the Situation. *The Journal of Philosophy.* XLI, 337-360.

Mittler, G. A. (March, 1980). Learning to look/looking to learn: A proposed approach to art appreciation at the secondary school level. *Art Education: Journal of the National Art Education Association, 33*(3), 17-21.

Mittler, G. (1973). Experiences in critical inquiry: Approaches for use in the art methods class. *Art Education: Journal of the National Art Education Association 26*(2) 16-21.

Newman, A. (September, 1982). Who needs art critics. *ARTnews.* 55-60.

Pepper, S. C. (1946). *The basis of criticism in the arts.* Cambridge: Harvard University Press.

Polanyi, Michael (1964). *Personal knowledge: Towards a post-critical philosophy.* New York: Harper & Row, Publishers.

Rader, Melvin (ed.) (1960). *A modern book of esthetics: An anthology.* New York: Holt, Rinehart and Winston.

Smith, R. (1973). Teaching aesthetic criticism in the schools. *Journal of Aesthetic Education, 7*(1), 38-49.

Taylor, Joshua C. (1957). *Learning to look: A handbook for the visual arts.* Chicago: University of Chicago Press.

Venturi, L. (1936). *History of Art Criticism.* New York: E. P. Dutton and Co. Inc.

Wallbank, T., Taylor, A, Bailkey, N. (1977). *Western Civilization: People and progress.* Glenview, Illinois: Scott, Foresman and Company.

Wolfflin, H. (1932). *Principles of art history.* New York: Dover Publications, Inc.